DRAW
GREAT

Characters and creatures

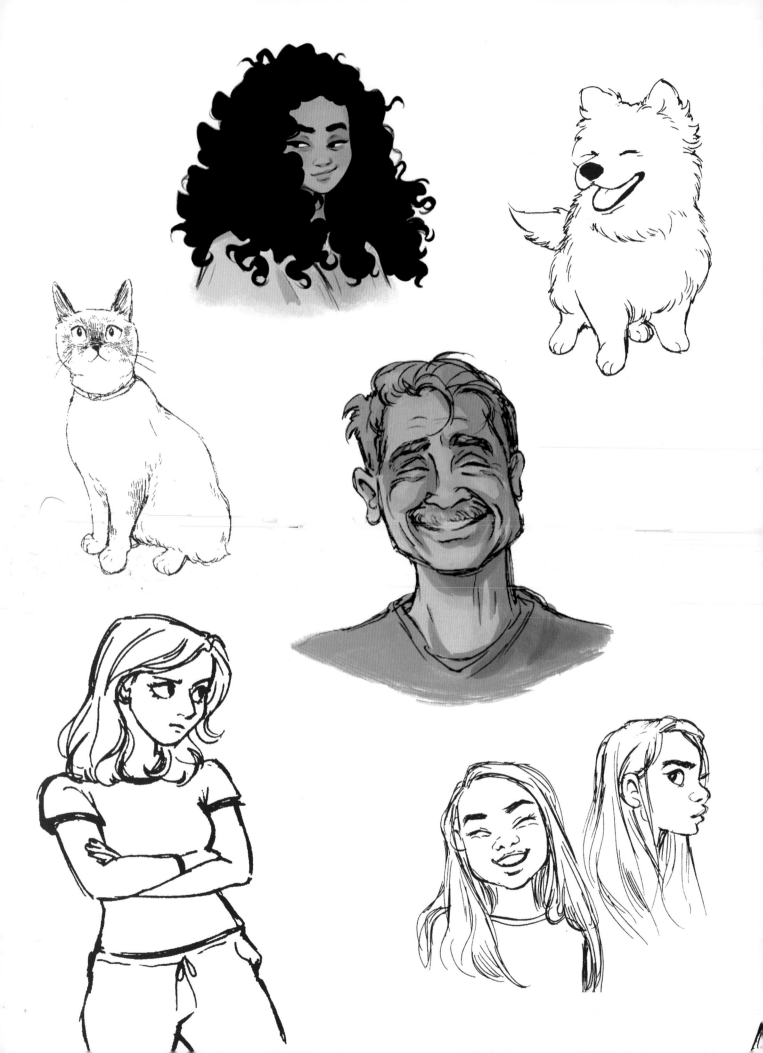

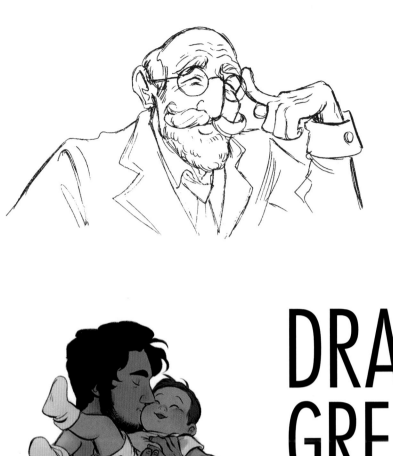

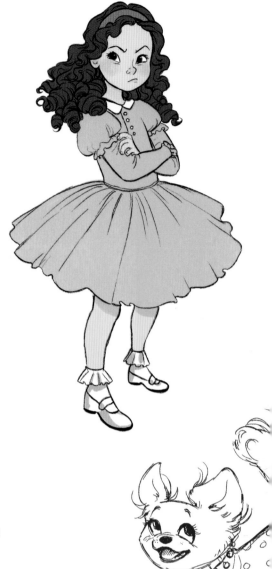

DRAW
GREAT
Characters
and creatures

75 ART EXERCISES FOR
COMICS AND ANIMATION

BEVERLY JOHNSON

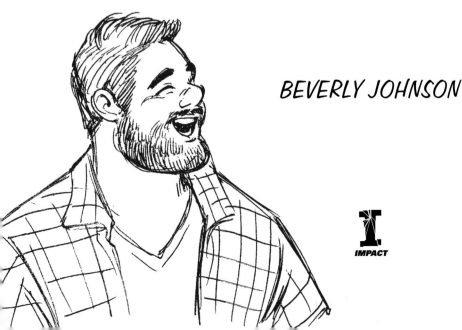

IMPACT

IMPACT

an imprint of Penguin Random House LLC
penguinrandomhouse.com

10 9 8 7 6 5 4

ISBN: 978-1-4403-0081-3

Conceived, edited, and designed by
Quarto Publishing,
an imprint of The Quarto Group,
6 Blundell Street, London N7 9BH
www.quarto.com

QUAR.307128

Senior editor: Kate Burkett
Senior art editor: Emma Clayton
Designer: Rachel Cross
Art director: Gemma Wilson
Publisher: Samantha Warrington

Manufactured in China

Additional artwork on pages 132–141:
Aneta Fonter

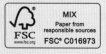

CONTENTS

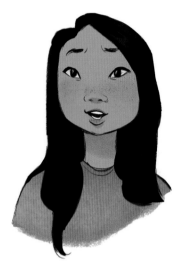

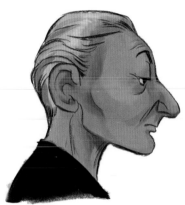

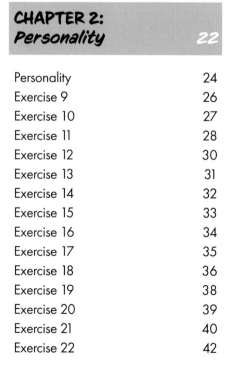

MEET BEV

I've always loved drawing, for different reasons at different times. It's always been a source of fun and comfort for me, but now it's my career as well! Many times, it's been my best outlet to express myself or vent; other times, it's pure fun and self-indulgence.

As a kid, I was obsessed with animated movies, fairy tales, and picture books. I drew magical kittens, princesses, castles, and fairies. One of my biggest influences was my Granny, who told me fantastical stories, sometimes scary ones. Another big influence was Sleeping Beauty, which helped me draw curly hair and understand that yellow with a brown shadow looks like gold.

Aged around 11, I got into comics such as *W.I.T.C.H.*, *Sailor Moon*, *Full Moon Wo Sagashite*, and *Bone*. I made fake magazines and drew fashion illustrations for them. Every day after homework—sometimes before, oops—I would draw a few pages of a comic, usually about magical girls or imaginary middle-school drama. I began to love creating my own characters and making animations (bizarrely on PowerPoint).

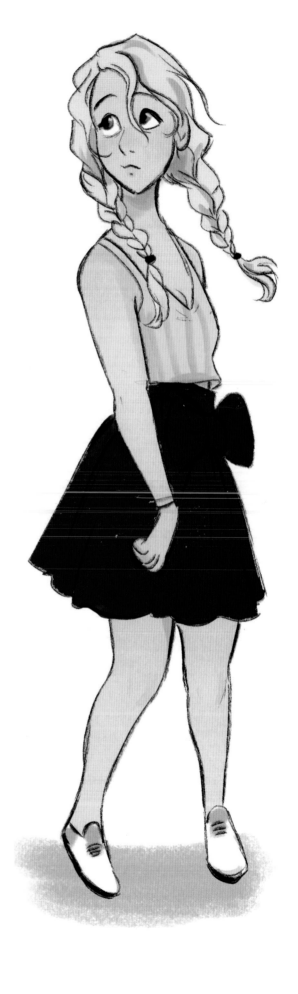

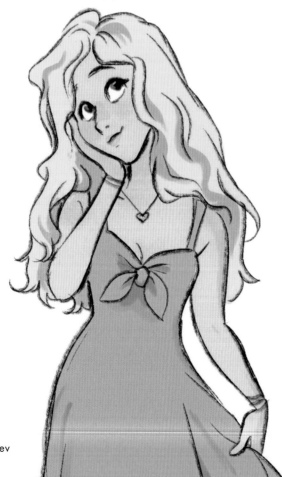

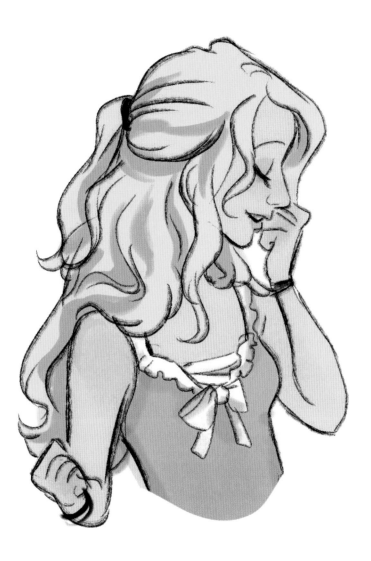

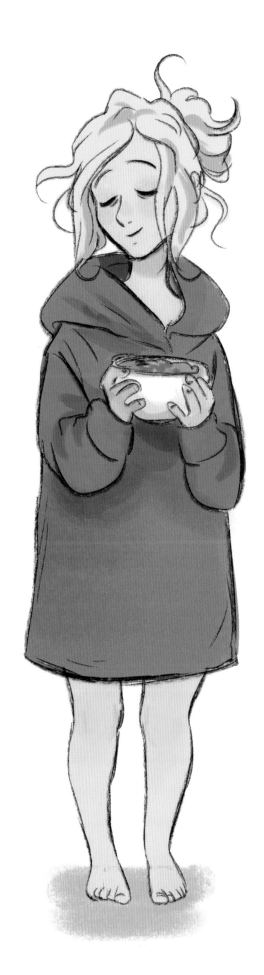

I started getting truly serious about art as a career at about 14. I wrote more and created more characters. I began posting my art online and researching art schools. I grew a lot as an artist in college, taking on new challenges and a heavier workload. I began dabbling in freelance and commissions. Getting into my top choice, Rhode Island School of Design, was really exciting!

One of the most surprisingly important lessons I learned in art school was what I absolutely didn't want to do career-wise—I did not enjoy or excel at 3D art, especially not the disaster of a chair I made for a freshman class. On the bright side, I deepened my love for characters and stories, and gained some valuable professional skills. One of the most helpful things for me was (and still is) sharing my work, as well as drawing what I am passionate about.

Now I do a variety of freelance work, mostly character design and children's illustration. I love what I do, and I feel really grateful that I'm able to do it for a living.

TOOLS AND MATERIALS

I work with a mixture of digital and analog tools, as do most professionals. Nothing can compare to the tactility of notebooks and sharpened pencils for sketching and drawing. I tend to draw on paper and then scan the image into my computer to finesse the linework. Or, sometimes, I draw directly onto my tablet. Do remember though that a computer can only be as creative as the person using it.

FOR DRAWING

1 Graphite pencils
Graphite pencils are available in different hardnesses, from 9H to H, F, HB, and B to 9B. In pencil-speak, "H" denotes hard, meaning the line will be very fine and light. "B" means soft, meaning the line will be darker and thicker. Softer, dark leads, such as B and 2B, are generally considered best for sketching. For finished figure work, use harder and lighter leads, such as 2H, H, and F, to avoid smearing and smudging the lead on the paper.

2 Mechanical pencil
A mechanical pencil generally uses thicker leads and comes in a variety of widths: 0.7 mm (thick line), 0.5 mm (the most commonly used), 0.3 mm (fine line), and 0.2 mm (the finest lines).

3, 4, 5 Fiber tips and Markers
Fine fiber-tip pens are particularly useful for rapid sketching. They are useful if you are sketching outdoors. They produce a slightly mechanical line, but this does not matter too much for sketching or for methods such as hatching and crosshatching.

6 White plastic eraser
This type of eraser is used to clean up large areas.

7 Kneaded eraser
A kneaded eraser that you can shape is good for cleaning up pencil smudges and unwanted construction lines.

8 Pencil sharpener
A metal sharpener is the easiest to control and does the best sharpening. If possible, find a sharpener for which you can buy spare blades.

9 Drawing compass
A compass with a pencil attachment is a technical tool for drawing circles of all sizes.

10 French curve
A French curve is handy for drawing clean, curved lines.

FOR COLORING

11 Watercolor paints
Watercolor paint generally comes in tubes, pans, and half pans, and is available in two forms: student quality and professional-artist quality (the latter is more expensive, but the pigments are brighter and punchier). Pans and half pans are designed to fit into a paint box. You can buy paint boxes with around 12 colors or—sometimes—fewer, but you may prefer to choose your own colors, since this allows you to start with a small range and build up gradually.

12 Paintbrushes
The best watercolor brushes are sables, but these are expensive and there are many excellent synthetic brushes and sable and synthetic mixtures that are perfectly adequate. Remember that the larger the brush size, the more paint it will hold, so make sure to have a choice of brush sizes for different applications. The lower the number, the smaller the brush tip.

13 Brush pens
Brush pens have a flexible tip that releases ink when pressure is applied. These water-based pens work a little like watercolor paints and blend effortlessly.

14 Watercolor markers
You can use watercolor markers to draw, just as you would with a regular marker pen. The transformation occurs when you apply water to what has been drawn, turning it into a watercolor painting. The sooner water is applied, the better the resulting washes. You can then blend the colors just as you would with traditional forms of watercolor.

Colored pencils [not shown]
These can be used for coloring or drawing. There are lots of different brands of colored pencil, and the colors and textures vary considerably. Some are hard and semi-transparent, some soft and opaque, and others waxy. Do some research and find a brand that suits your art style.

SUPPORTS FOR DRAWING AND PAINTING

15 Tracing paper
Sheets of tracing paper with individual drawings on each can be overlaid to work out composition and layout ideas.

16 Drawing paper
Many types of drawing paper can be bought, not only in loose sheets but also in pads. Cartridge paper is the most suitable for pencil drawings. Acid-free paper is recommended for permanence.

Watercolor paper [not shown]
Watercolor paper can be bought in pads and is hot- or cold-pressed. Hot-pressed paper has a smoother finish that makes it good for painting fine details, and it doesn't absorb water too quickly. Cold-pressed paper has an obvious "tooth" (that is, a surface texture), which means it absorbs water more quickly and gives a more textural and undefined finish overall.

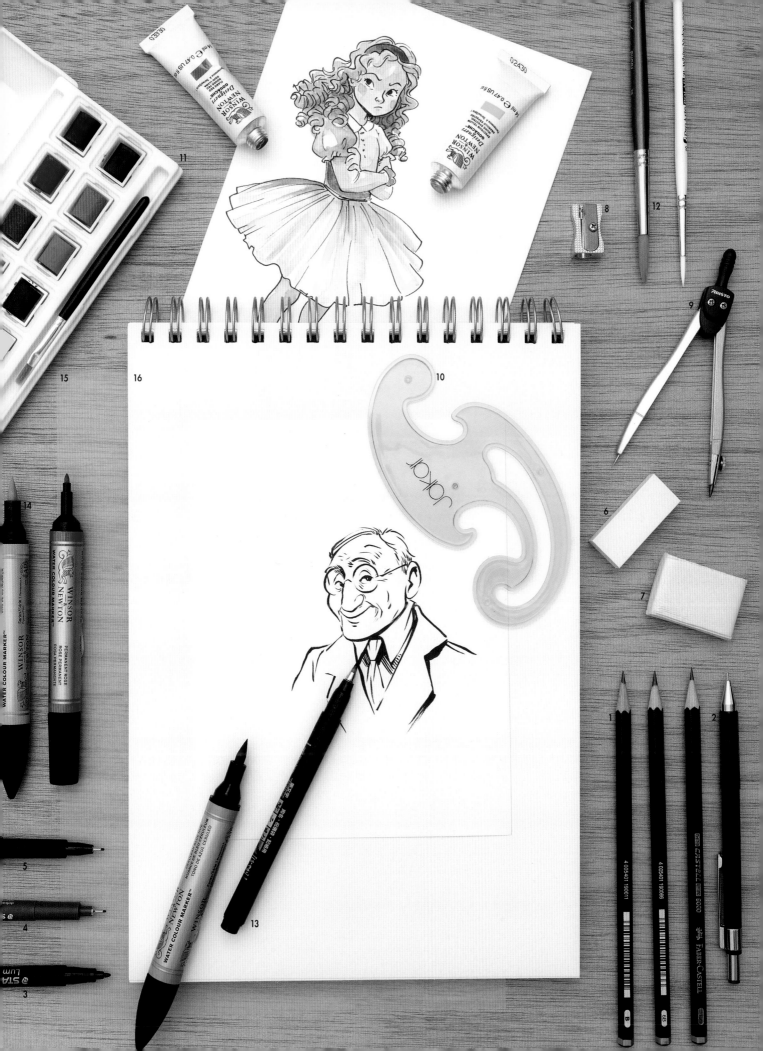

SHAPE
LANGUAGE

In this chapter, we will be exploring the basic shapes that help build our characters. Shapes are used to communicate themes and ideas, and have prescribed meanings that evoke certain emotions and feelings. We seem to be hardwired to associate particular shapes with certain moods, emotions, or expectations. Essentially, shapes can suggest positive, negative, or neutral feelings.

Curved and circular shapes are considered the friendliest. They tend to be soft and harmless, and evoke likable characters. Square-like shapes communicate strength, stability, and confidence. They can be large and daunting or comforting and clumsy, and often depict steadfast characters who are dependable. Triangles relate to diagonal and strong, angular lines and are the most dynamic. Bad guys are often based upon triangular shapes, as they appear malicious and sinister.

Shape language in design has a way of communicating universally and is therefore the best place to start building your character.

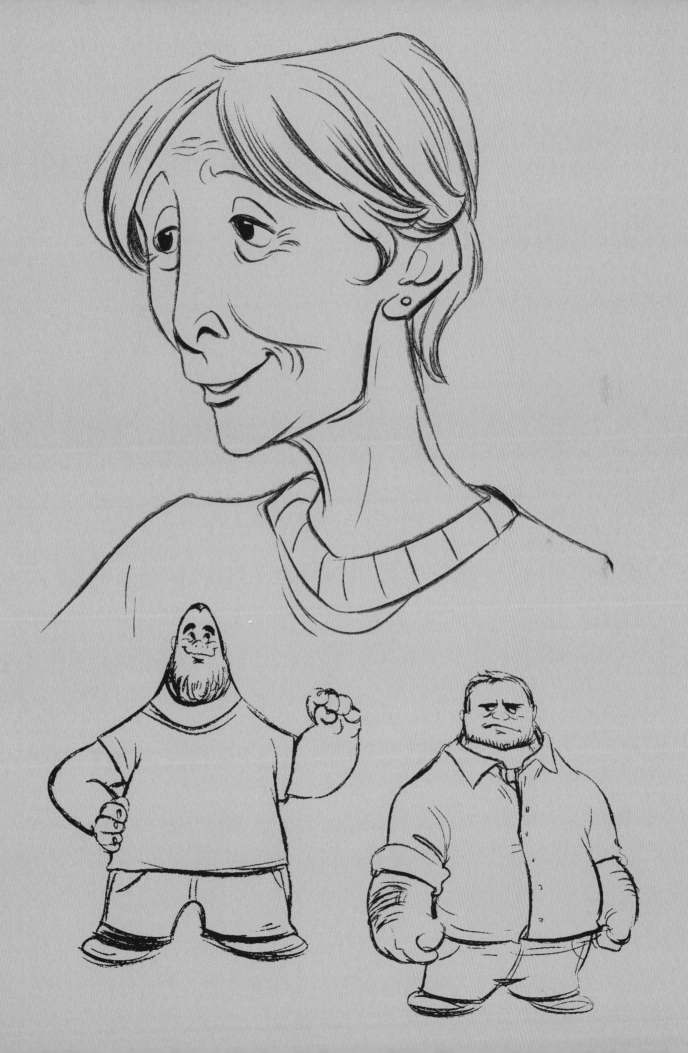

EXERCISE 1

The most challenging question for any artist is: "Where do I start?" Although basic shapes, such as circles, squares, and triangles, are the building blocks of drawing, you can use absolutely any shape you like as the foundation for a character. So here's a simple exercise to free up your mind and hand, and get you started. Just put some random shapes on paper, see what they suggest to you, and then build some characters from them.

Sketch any shape you like, and then find the character within it.

DRAWING PROMPTS

Make your shapes completely random to begin with—just put them down on paper without thinking about what they might represent. Make some fat, some thin, some rounded, some with jagged or wavy edges—then stand back and imagine what character might have that kind of shape.

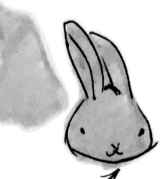

Your shapes might not always suggest an entire figure—I turned this shape into a rabbit's head.

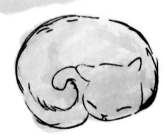

Even a simple shape can inspire a detailed character.

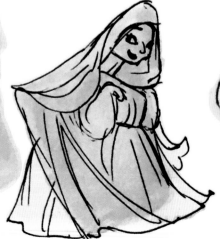

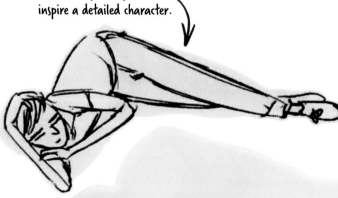

EXERCISE 2

Now let's try working with very specific shapes that you might not immediately associate with characters. Who might be built like a brick, or round like an apple? Yes, these are exaggerated shapes—but they'll help you determine what makes each character unique.

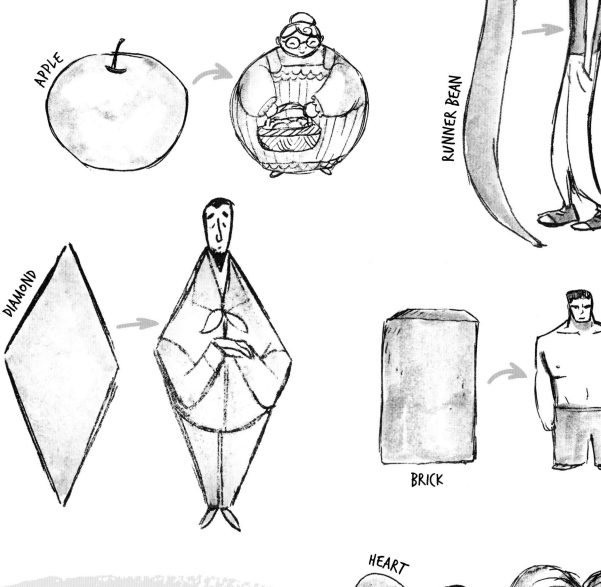

DRAWING PROMPTS

Use your artistic eye to look within each shape, as well as to study its outline. Don't be afraid to sketch beyond the shapes as well.

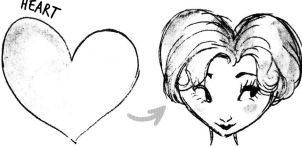

EXERCISE 3

Choose different types of characters and bring them to life using basic shapes. Your chosen shape could be sharp and angular, like a triangle, soft like a pear, or expansive like a star. This time, focus on your imagined characters first, then decide what shape best fits them.

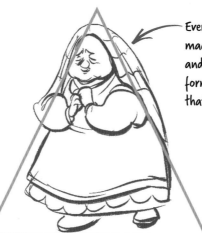

Even a character made of soft curves and circles can still form an overall shape that is very angular.

Note that the character need not fit the shape exactly.

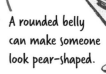

A rounded belly can make someone look pear-shaped.

DRAWING PROMPTS

Who is your character? A thoughtful instructor may have a belly that makes him look pear-shaped. A strong, stalwart fellow may have big arms and a broad chest that make him more reminiscent of an apple. What shape does your character bring to mind?

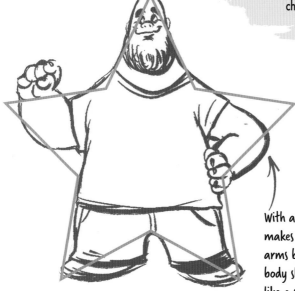

With arms flexed, this figure makes a star shape; with his arms by his side, his overall body shape would be more like a squat rectangle.

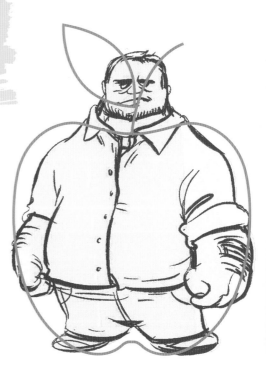

EXERCISE 4

Draw a character composed of SOFT, CIRCULAR shapes.

DRAWING PROMPTS

Here are some ideas for a character with soft shapes and flowing lines: a lady relaxing on the beach, a big superhero with bulging muscles, a looming ogre, or a kindly old grocer with an apron around his well-fed belly.

Note how, with different poses, the oval shapes can extend to more than just the torso and head.

As our character changes her pose, the soft feel is continued in the flow of her hair.

With a character made of soft shapes, even movements and gestures maintain a smooth pattern.

EXERCISE 5

Draw a solid, stable character based mostly on SQUARE shapes.

DRAWING PROMPTS

Square-shaped characters often impart a feeling of reliability or trustworthiness. Who might fall into this category? Perhaps a strong linebacker or a stern but caring school teacher? Or a trusted neighborhood police officer?

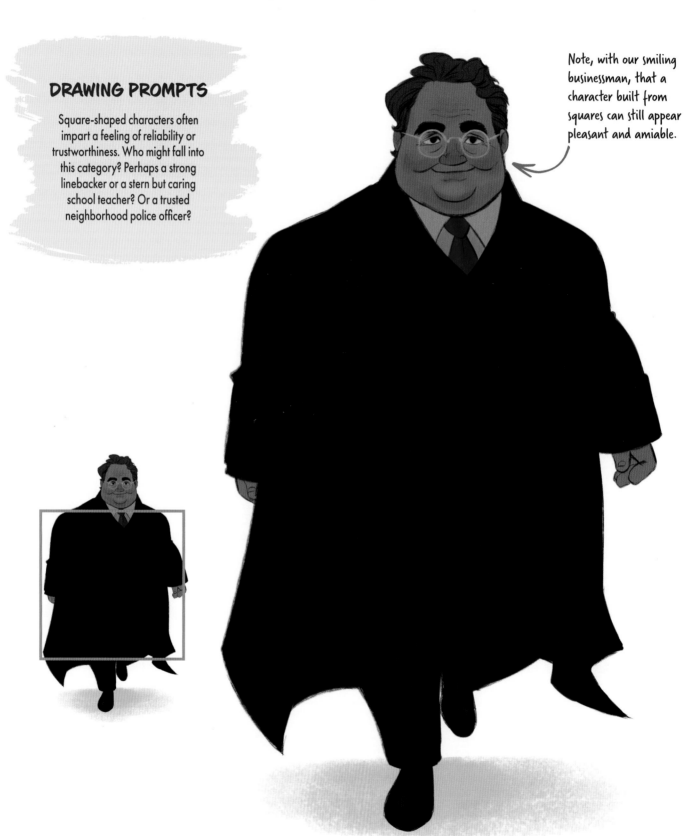

Note, with our smiling businessman, that a character built from squares can still appear pleasant and amiable.

Draw a sharp, strong character based mostly on TRIANGULAR shapes.

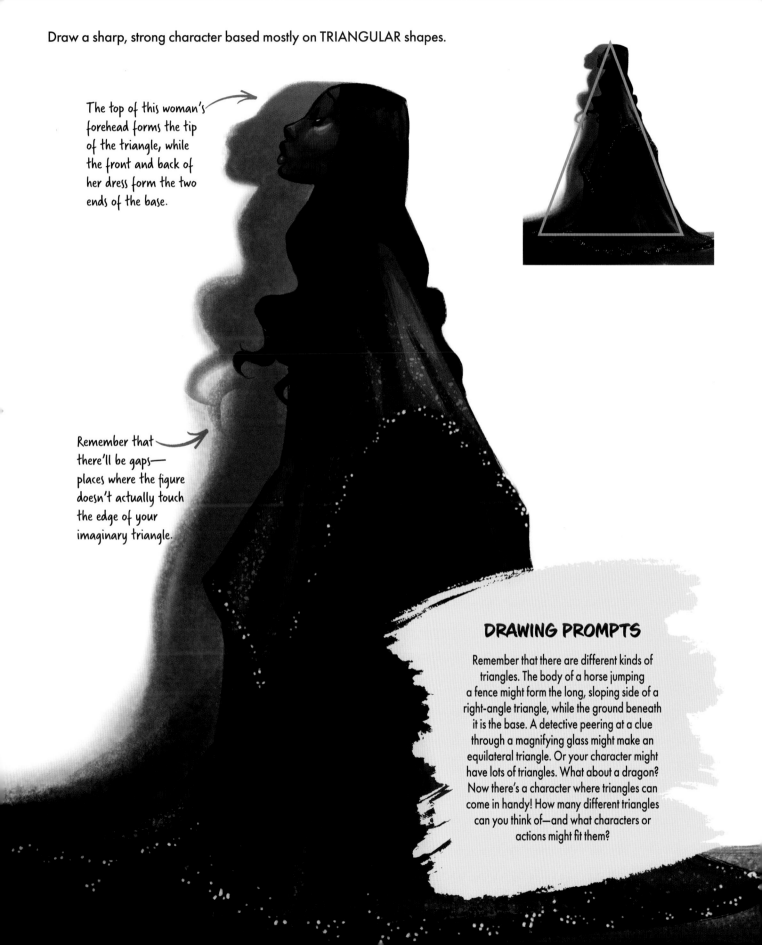

The top of this woman's forehead forms the tip of the triangle, while the front and back of her dress form the two ends of the base.

Remember that there'll be gaps—places where the figure doesn't actually touch the edge of your imaginary triangle.

DRAWING PROMPTS

Remember that there are different kinds of triangles. The body of a horse jumping a fence might form the long, sloping side of a right-angle triangle, while the ground beneath it is the base. A detective peering at a clue through a magnifying glass might make an equilateral triangle. Or your character might have lots of triangles. What about a dragon? Now there's a character where triangles can come in handy! How many different triangles can you think of—and what characters or actions might fit them?

EXERCISE 7

Draw a soft, bubbly character based mostly on ROUND shapes.

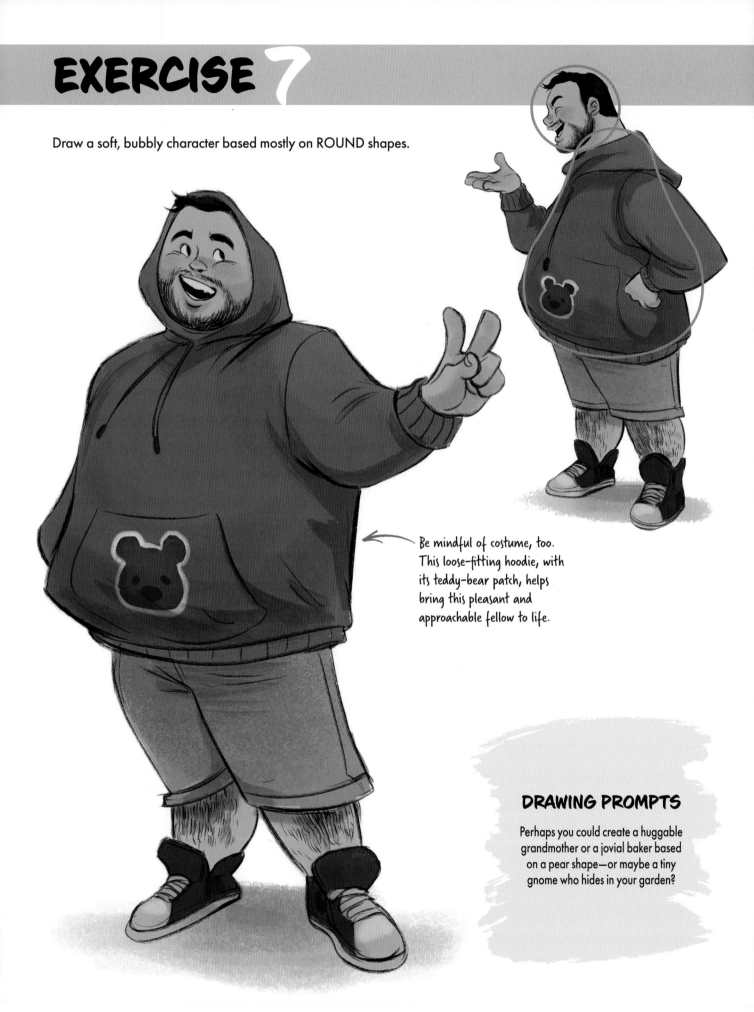

Be mindful of costume, too. This loose-fitting hoodie, with its teddy-bear patch, helps bring this pleasant and approachable fellow to life.

DRAWING PROMPTS

Perhaps you could create a huggable grandmother or a jovial baker based on a pear shape—or maybe a tiny gnome who hides in your garden?

Subvert the usual shape language—try drawing a sharp-looking character that is kind, shy, and sweet, or a soft-looking character that is cold and calculating.

A circular, round character need not always be cuddly.

DRAWING PROMPTS

Turn things around! What might make a rounded, cuddly-looking character look mean and moody—their facial expression, body language, clothes? How could you make a thin, angular figure look like someone you'd like to snuggle up to?

An angular or aquiline face can be made to appear gentle and welcoming.

PERSONALITY

One of the most defining things about your characters will be their personality. There are many ways to define a character's personality: through their physical look, their attire, their expressions, and their movement. Sometimes you can tell what a character's personality is just by looking at them. Other times, you don't know until the character is shown in different poses or situations, and, of course, when interacting with other characters. This is your chance to really delve into how to craft your characters' personalities, so let's get started!

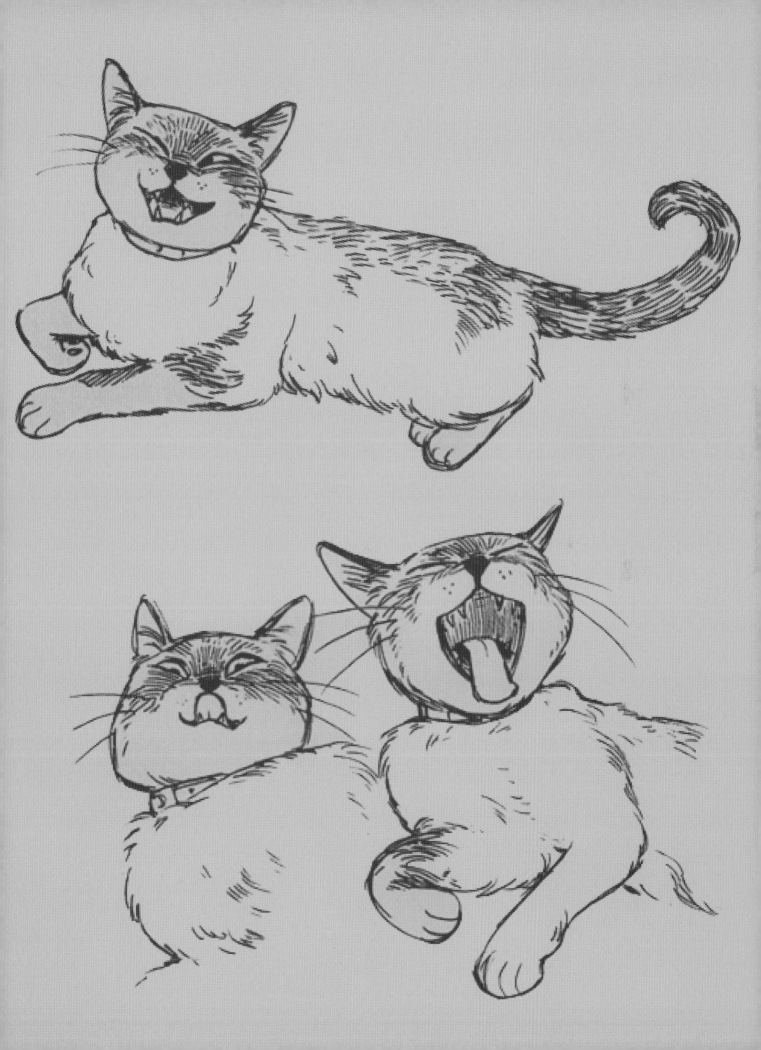

EXERCISE 9

Put your music on shuffle and draw a character based on each song. He or she can be a person mentioned in the song or just a character based on the abstract feeling of the song.

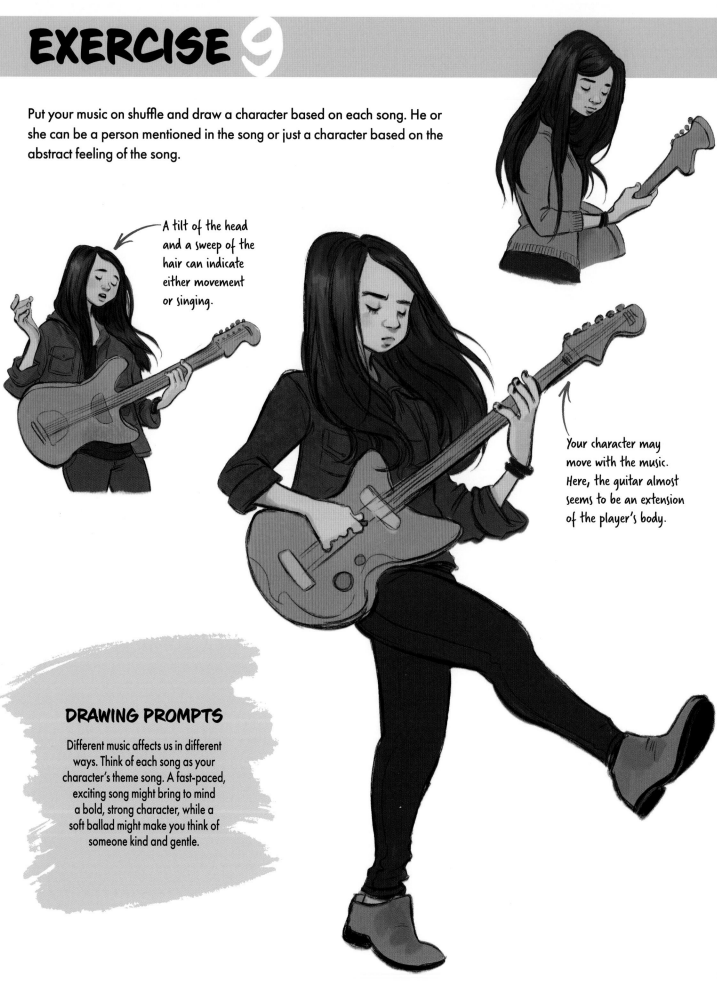

A tilt of the head and a sweep of the hair can indicate either movement or singing.

Your character may move with the music. Here, the guitar almost seems to be an extension of the player's body.

DRAWING PROMPTS

Different music affects us in different ways. Think of each song as your character's theme song. A fast-paced, exciting song might bring to mind a bold, strong character, while a soft ballad might make you think of someone kind and gentle.

EXERCISE 10

Draw the complete opposite of yourself—your foil. Think about both physical traits (hairstyle, clothes, accessories, where you tend to spend most of your time, and so on) and emotional ones (expression and body language, for example).

This character's serious expression and downward gaze mark her out as someone thoughtful, perhaps even introverted.

Sleek and sophisticated, this character is the very antithesis of a tomboy who spends her life climbing trees and having adventures in the wild.

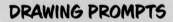

DRAWING PROMPTS

Think about what makes you you and what traits your foil character would have. If you like sports, for example, perhaps your opposite would prefer to stay inside reading a book. Or, if you spend your life in jeans and a T-shirt, maybe your foil would be dressed to the nines in glamorous eveningwear and expensive jewelry.

EXERCISE 11

Draw your favorite literary characters. Think of what features and personality traits you want to emphasize about them.

Here, I have drawn *Jane Eyre's* anti-hero, Mr. Rochester—a dark, brooding, and mysterious character—and *Charlie and the Chocolate Factory's* Veruca Salt—an extremely selfish, over-indulgent little girl who wins a greatly desired golden ticket.

Facial features, such as the bushy eyebrows, stern gaze, and thin lips, emphasize Mr. Rochester's gruff personality.

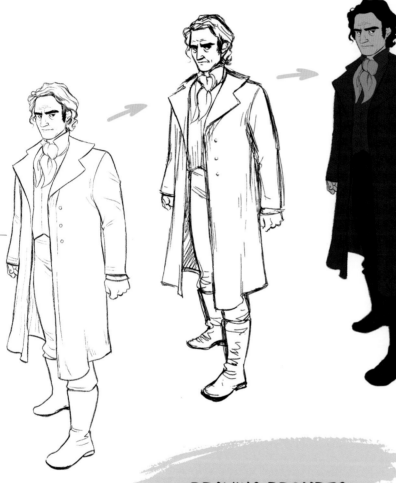

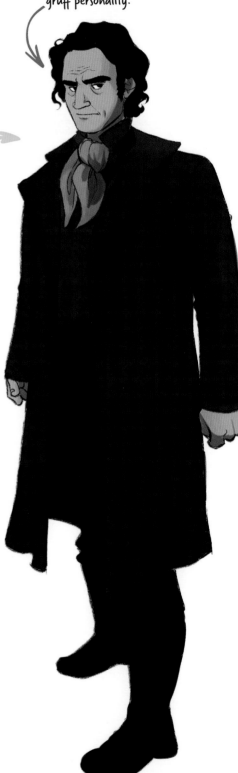

DRAWING PROMPTS

Characters from literature can have elaborate costumes and styling. Remember to start out rough—draw general to specific—and once you have the feel of your character on the page, you can clean up the linework, and even begin to add color and details. It need not look perfect right away! Take your time and enjoy the creative process.

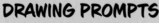

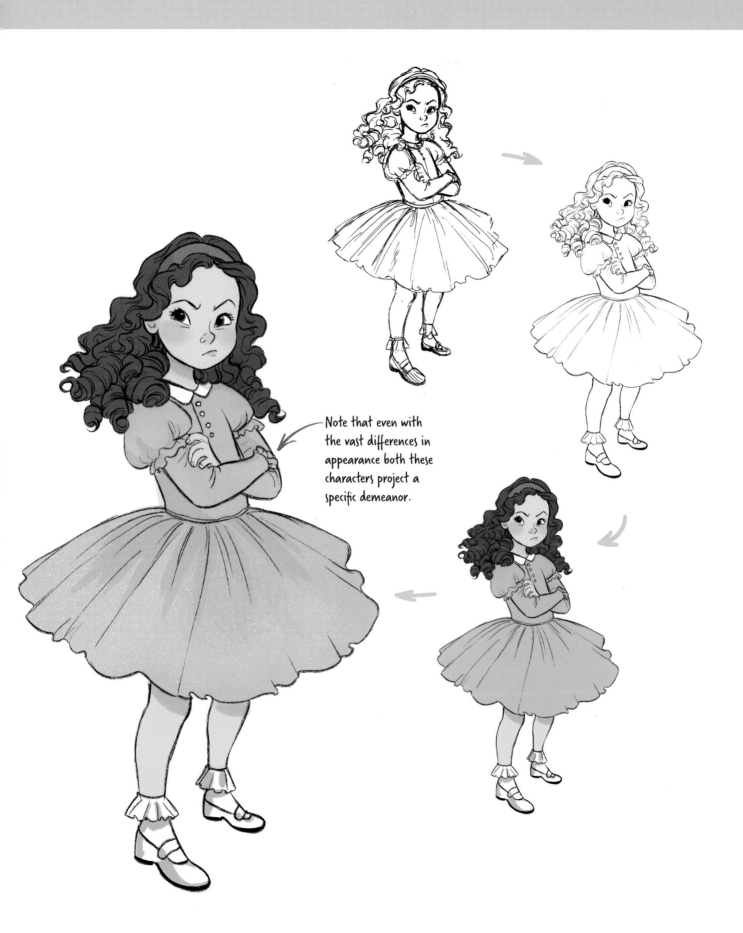

Note that even with the vast differences in appearance both these characters project a specific demeanor.

EXERCISE 12

Think of five foods or drinks. Design characters around them.

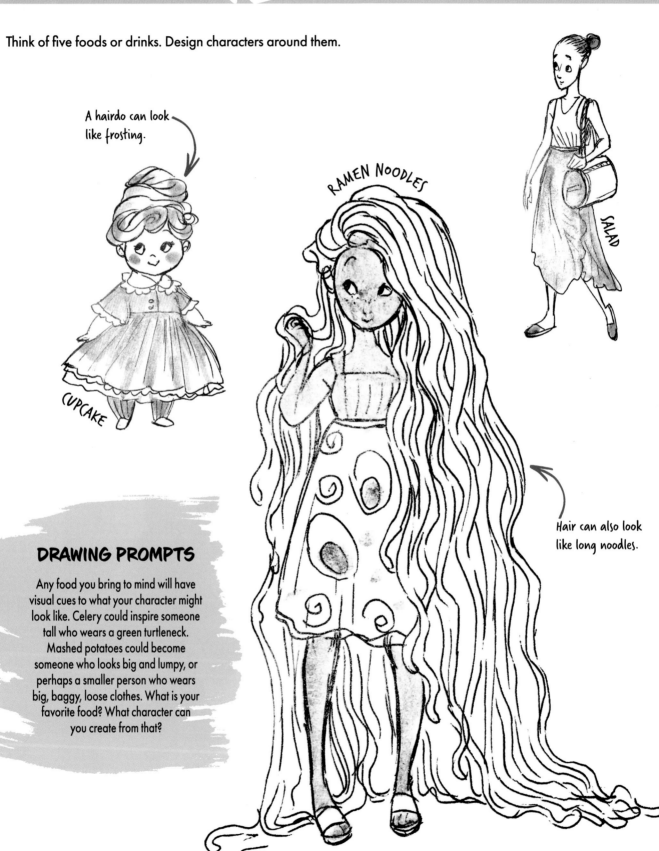

A hairdo can look like frosting.

CUPCAKE

RAMEN NOODLES

SALAD

Hair can also look like long noodles.

DRAWING PROMPTS

Any food you bring to mind will have visual cues to what your character might look like. Celery could inspire someone tall who wears a green turtleneck. Mashed potatoes could become someone who looks big and lumpy, or perhaps a smaller person who wears big, baggy, loose clothes. What is your favorite food? What character can you create from that?

EXERCISE 13

Pick a villain and redesign them as a hero or heroine, or vice versa.

When creating your new hero/heroine or villain characters, think of the differences in features, dress, posture, and movement. Think of *who* your characters are as well as what they look like. Here, the curious Alice becomes a petulant brat, while the evil Red Queen is now a cheerful matron.

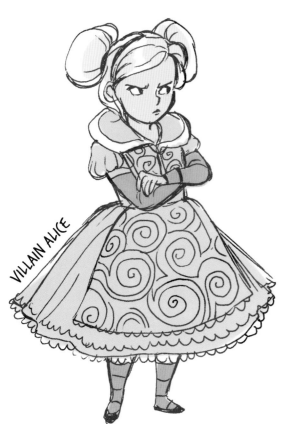

VILLAIN ALICE

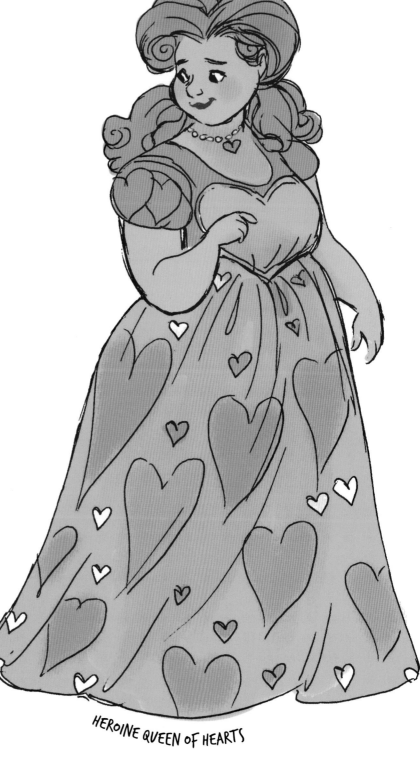

HEROINE QUEEN OF HEARTS

DRAWING PROMPTS

Think of a pair of contrasting characters in a favorite story, then swap their personalities over and see how their appearance changes. For example, what would Harry Potter look like if he were as evil and dangerous as Lord Voldemort? In the *Batman* movies and comic books, what would the Joker look like if he was trying to save the world rather than destroy it?

EXERCISE 14

Design characters based on these words: Somber, Regal, Ethereal.

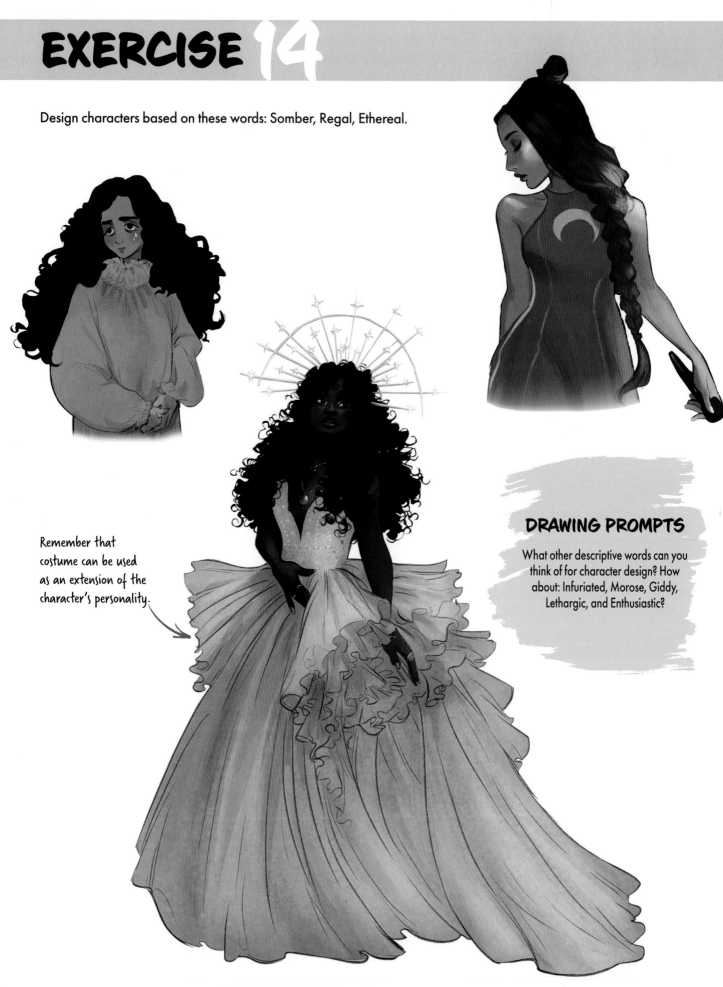

Remember that costume can be used as an extension of the character's personality.

DRAWING PROMPTS

What other descriptive words can you think of for character design? How about: Infuriated, Morose, Giddy, Lethargic, and Enthusiastic?

Draw characters that embody a very specific thing, animal, object, or visual.

This girl is drawn from the word "Rainbow." Look at her sleeveless top, her free-flowing hair, the glitter makeup on her cheeks, her cheerful expression. These all help to indicate a personality as bright and colorful as the trim on her collar. What words can you come up with?

DRAWING PROMPTS

Consider a variety of words that bring one thing to mind, and design a character based on those. For instance, what comes to mind when you think of the following:

- Sunshine
- Storm cloud
- Wolf
- Swamp
- Redwood

EXERCISE 16

Draw kids of different ages, body types, and personalities.

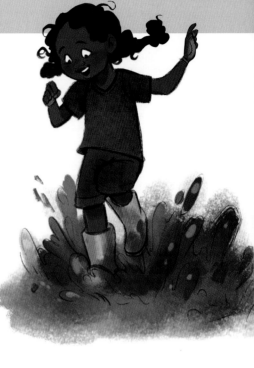

Young children's heads are large in relation to their bodies. A toddler's head makes up just over one-quarter of the child's total height.

DRAWING PROMPTS

Take inspiration from family, friends, neighbors, kids at school, even strangers on the street. Who around you would make a good character? Remember there is no set "kid" size—draw some tiny, large, lanky, or broad! You might choose to draw a happy-go-lucky toddler, a bratty first-grader, or even an angry pre-teen.

Because her overalls are covered in paint, you can imagine this girl likes to be creative—even if all she's creating is a mess!

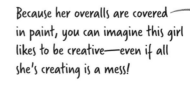

EXERCISE 17

Choose some household objects and design characters based on them.

Get creative! It's easy to think of a lampshade as a hat. Here, it becomes the character's tiny head and big hairdo.

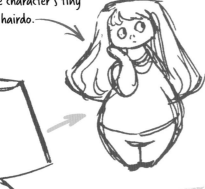

The characters can be different sizes from the items themselves.

DRAWING PROMPTS

Walk around your home and list as many objects as you can see. There will be a lot, I'll bet! Bring characters to life from things such as:

Table • TV remote • Potted plant • Rocking chair • Microwave • Cooking utensils

Some transformations are easy—this mop head makes perfect straggly hair!

EXERCISE 18

Choose a pet or simply an animal you like, observe their mannerisms, and try to capture their personality through gesture and expression.

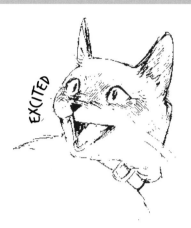

EXCITED

PROUD

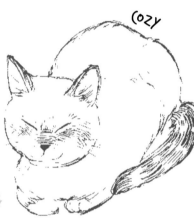

COZY

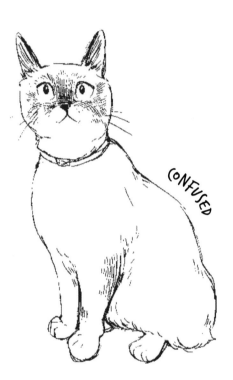

CONFUSED

DRAWING PROMPTS

Do you have a pet? If not, a favorite animal? How would you describe their personality? Observe how they move and express themselves. Are they affectionate, shy, or energetic? Practice sketching them—you can stylize and exaggerate all you want.

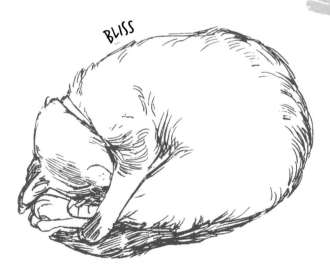

BLISS

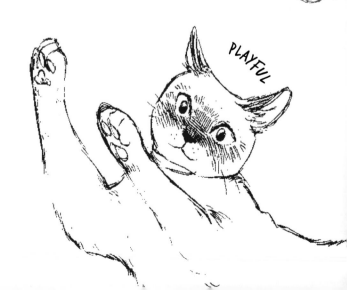

PLAYFUL

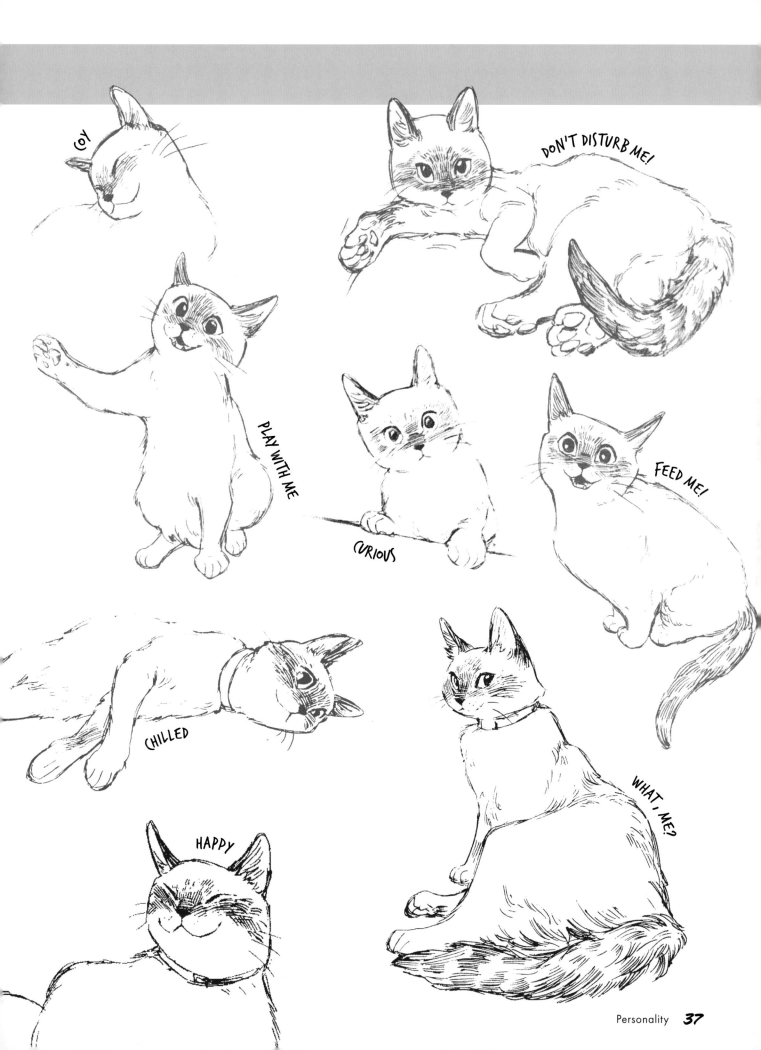

COY

DON'T DISTURB ME!

PLAY WITH ME

CURIOUS

FEED ME!

CHILLED

WHAT, ME?

HAPPY

Relatives tend to resemble each other in looks and intelligence, but not personality. Draw two family members with different personality traits.

DRAWING PROMPTS

Keep in mind that drawings of family members could be a combination of body types, personality, clothing, and even items they may carry. Think of your own family. Are there members who are very different from each other? In what ways? Capture those differences in your drawings.

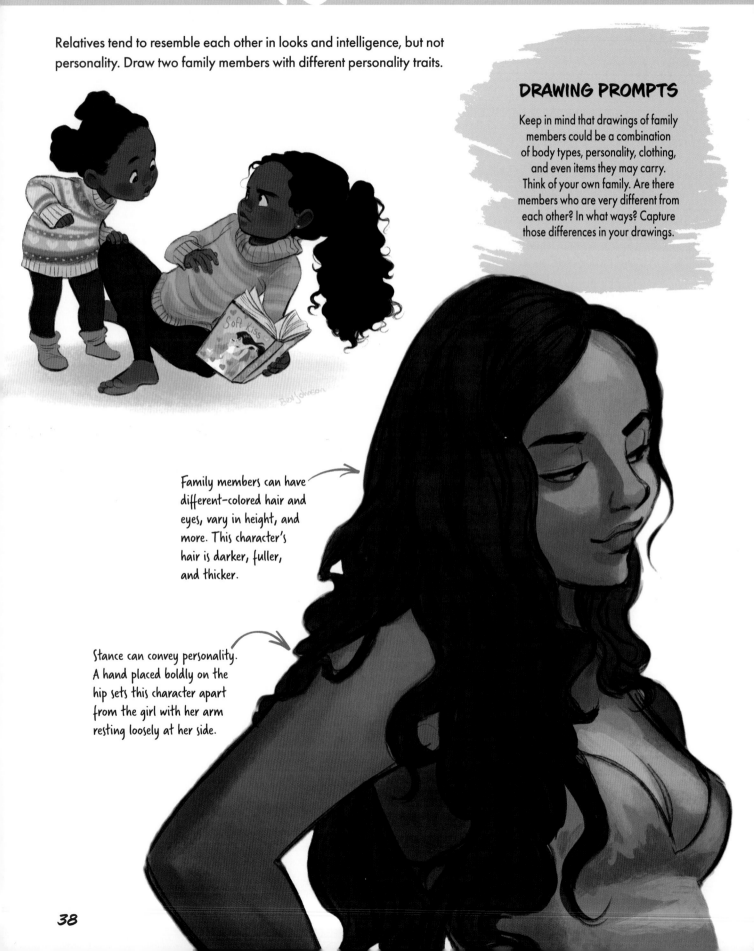

Family members can have different-colored hair and eyes, vary in height, and more. This character's hair is darker, fuller, and thicker.

Stance can convey personality. A hand placed boldly on the hip sets this character apart from the girl with her arm resting loosely at her side.

Think about archetypes, and how you can express them and perhaps also subvert them.

An archetype is a very simple, or sometimes considered, "classic" example of a particular thing, person, or idea.

This character's hair is not only lighter and more wispy, but having it tied back also indicates a reserved nature that matches her posture.

DRAWING PROMPTS

How might you draw an archetype with lots of detail? How might you do it in as simple a way as possible? Create your own version of characters based on these archetypes:

Villain • Hero • Everyday guy/girl • Adventurer/explorer • Rebel • Romantic • Jester/fool • Wise Person • Caregiver • Artist/creator

Design characters from your favorite fairy tale, play, or novel.

Many stories in literature draw upon the rich/poor contrast. *Oliver Twist*, *The Prince and The Pauper*, *The Outsiders*, and *Cinderella* are all good examples. Create your own characters in this dynamic in a modern-day setting. Choose a different setting and imagine these character types in the far-flung future or on a distant planet.

 One of the most classic and archetypal stories is that of rich and poor, the Haves and the Have-Nots. The penniless Cinderella and her wicked stepmother (below) are examples of such characters in a much-loved story. The orphaned child Cosette, in *Les Misérables* (opposite), is another.

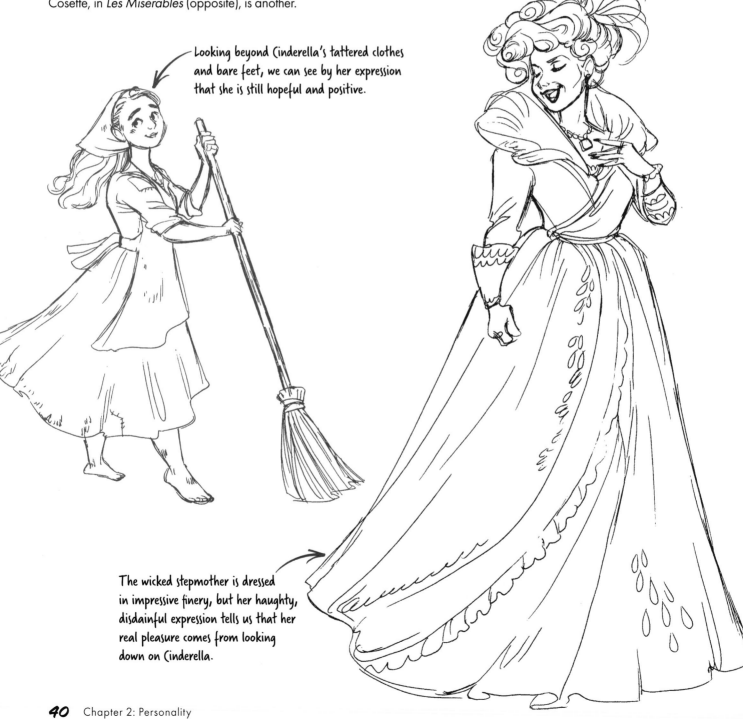

Looking beyond Cinderella's tattered clothes and bare feet, we can see by her expression that she is still hopeful and positive.

The wicked stepmother is dressed in impressive finery, but her haughty, disdainful expression tells us that her real pleasure comes from looking down on Cinderella.

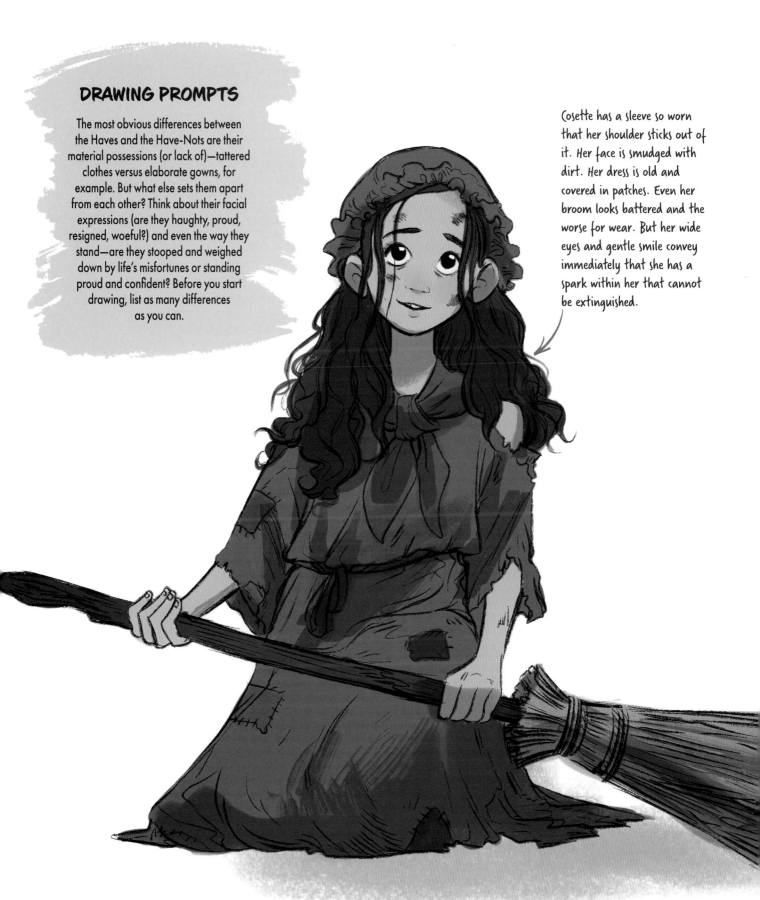

DRAWING PROMPTS

The most obvious differences between the Haves and the Have-Nots are their material possessions (or lack of)—tattered clothes versus elaborate gowns, for example. But what else sets them apart from each other? Think about their facial expressions (are they haughty, proud, resigned, woeful?) and even the way they stand—are they stooped and weighed down by life's misfortunes or standing proud and confident? Before you start drawing, list as many differences as you can.

Cosette has a sleeve so worn that her shoulder sticks out of it. Her face is smudged with dirt. Her dress is old and covered in patches. Even her broom looks battered and the worse for wear. But her wide eyes and gentle smile convey immediately that she has a spark within her that cannot be extinguished.

EXERCISE 22

A character doesn't always have to be a person: a setting can have a character and personality all of its own.

Note the positive feel of this room—the bright color of the walls, the repeated floral design on the curtain and rug. The room projects a personality all its own, even before we see the cheerful, smiling faces of the mother and child.

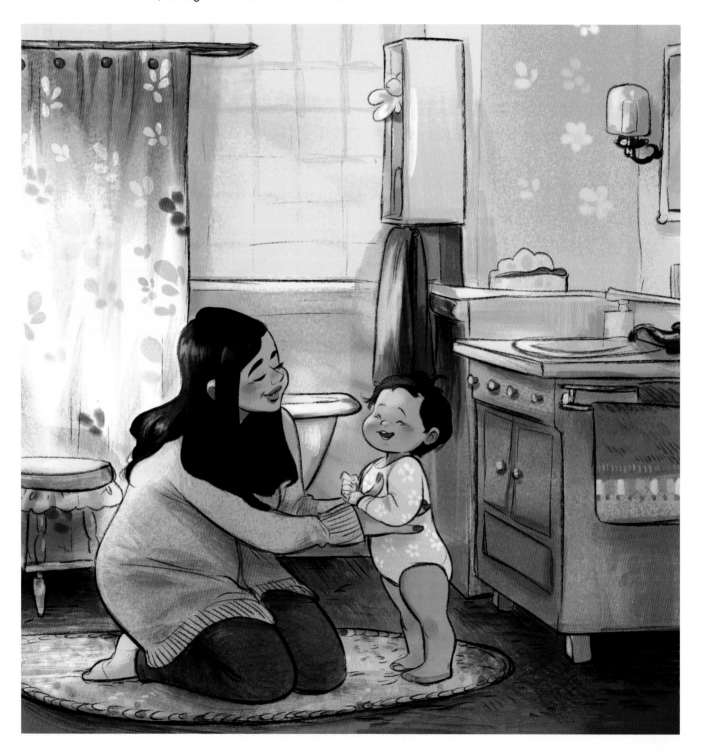

DRAWING PROMPTS

Think of different settings and how you can give them a mood to match the story you're creating. A house: welcoming or haunted? A forest: full of foreboding or a place of magic and delight? A room streaked with moonlight: the setting for a romantic tryst or a place where monsters lurk?

FACES AND EXPRESSIONS

The face is almost always the main focal point of any character design. It is an index of each character's personality. For example, large eyes may give a face a juvenile or innocent quality, while a high forehead may bestow intelligence, and so on.

Facial expressions are key to expressing emotions. They are a form of nonverbal communication and can vary from expressively large and easy to read to subtle and ambiguous. They can be voluntary or involuntary, and, when amplified or qualified by posture and gesture, can convey every facet of human emotion and even individual thoughts. High-arching eyebrows disappearing into the hairline and a wide-open mouth can communicate shock or surprise, whereas gritted teeth and lines in the forehead relay pain.

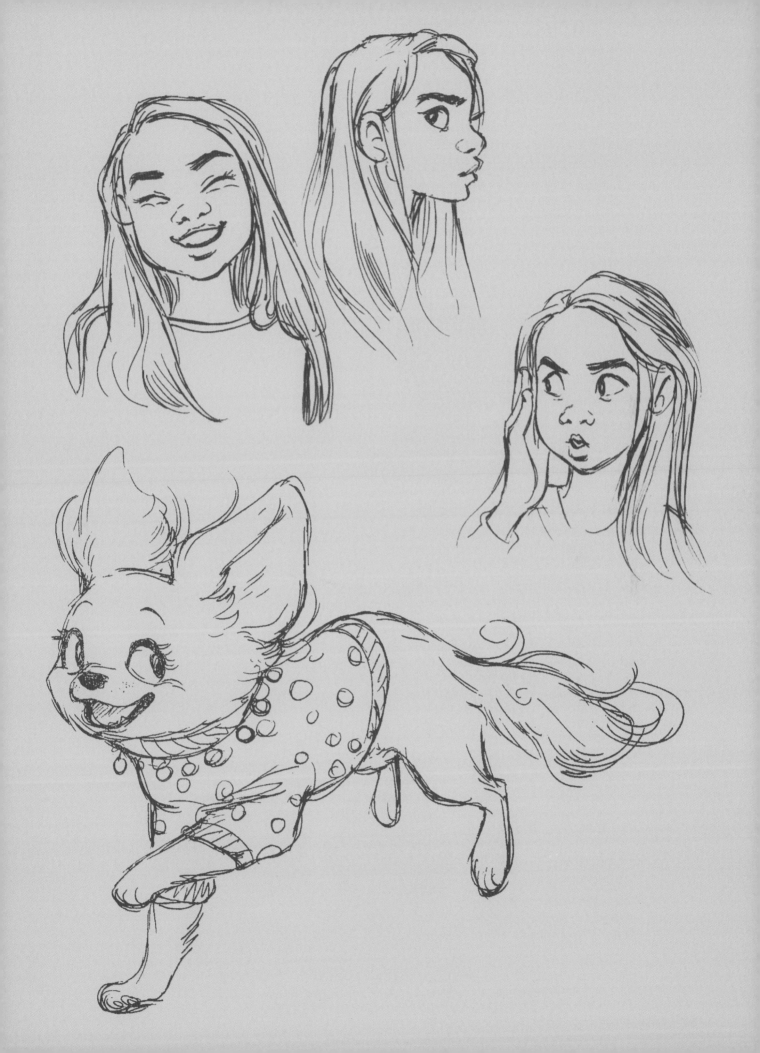

EXERCISE 23

Watch a movie and pause it on random frames to study the characters' expressions—then try to replicate these quickly, perhaps even exaggerating them so that you begin to get a feel for the "essence" of each expression.

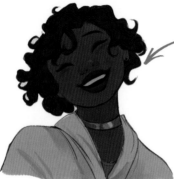

In laughter, the head often tilts backward.

The eyes (wide open, staring, or partially closed) and the direction of gaze (off to one side or looking directly at us) provide vital clues to the character's mood.

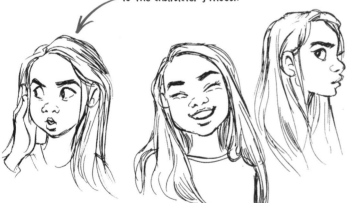

DRAWING PROMPTS

Revisit great movie moments.

- Draw Leonardo DiCaprio's Romeo when he discovers Juliet is dead.

- Or Mark Hamill's Luke Skywalker when Darth Vader reveals that he is Luke's father.

- How about when Diana first steps out onto No Man's Land in *Wonder Woman*?

Draw some of the more subtle movements and expressions of those on screen, too, such as a slight tilt of the head or quizzically raised eyebrows.

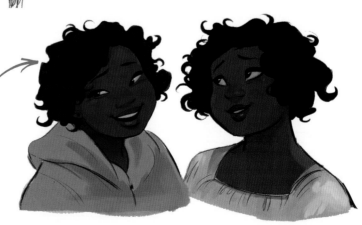

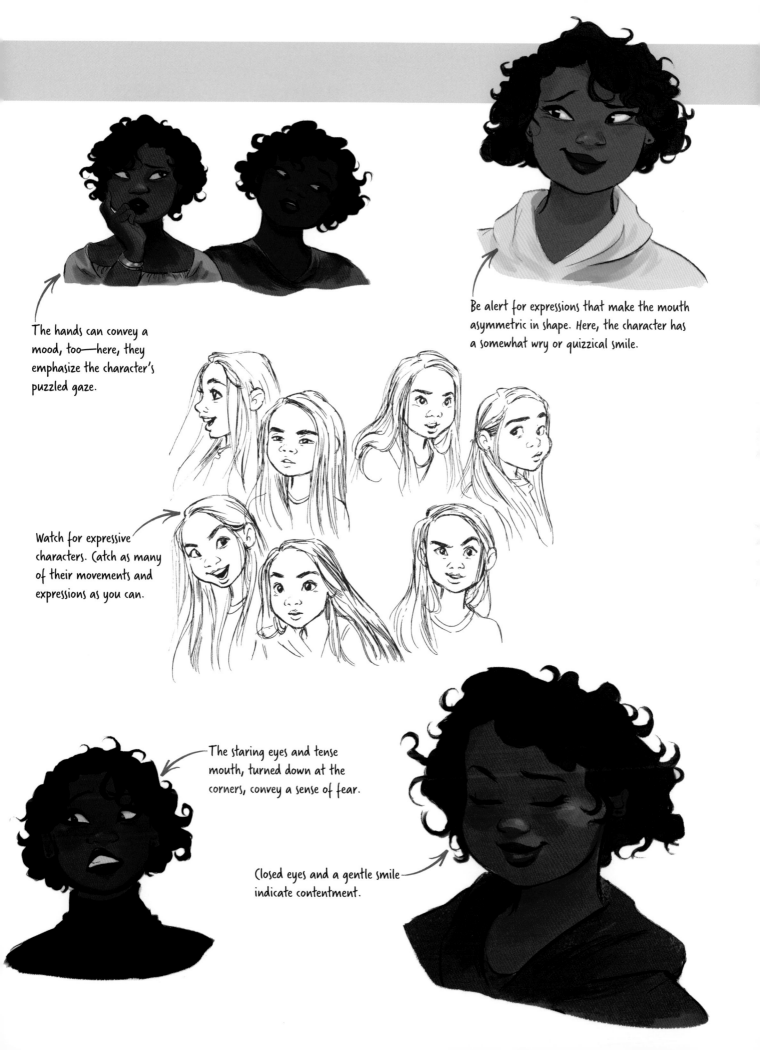

The hands can convey a mood, too—here, they emphasize the character's puzzled gaze.

Be alert for expressions that make the mouth asymmetric in shape. Here, the character has a somewhat wry or quizzical smile.

Watch for expressive characters. Catch as many of their movements and expressions as you can.

The staring eyes and tense mouth, turned down at the corners, convey a sense of fear.

Closed eyes and a gentle smile indicate contentment.

Practice drawing the subtle changes in expression that help give your character life.

Costume can add subtle touches to the character's mood and personality.

DRAWING PROMPTS

The best way to bring your characters to life is to study real people. Take a ride on a bus, or sit on a bench in the park or at a mall. Watch for the subtle changes in expression that indicate big changes in a person's attitude, mindset, and thought processes. The slightest change in expression of the eyes can switch your character from languid to alert, from distracted to slyly focused.

Some people squint when they smile; Others may clench their teeth to hold back a burst of laughter.

Slight changes can make a big difference in how your character is perceived. Are we seeing a happy smile or a snide smirk?

EXERCISE 25

Try to convey expressions using as few details as possible—think emoticons.
What are some shortcuts to convey different expressions?

As with emoticons, you may not need to see more than the character's head to express a wide range of feelings.

DISTRACTED

GOLDEN-RETRIEVER SMILE

CONCENTRATING

DRAWING PROMPTS

Bring to mind people you know—animals too, if you can! What slight changes in expression or posture signal to you what they are feeling? Try these on for size and see if you can transfer them to the page:

Heartbroken • Furious • Discouraged • Paranoid • Anxious • Lovesick • Empowered • Enthralled • Ecstatic

TALKING PASSIONATELY

EXERCISE 26

Make a bunch of expressions in the mirror, ranging from somber to ridiculous. Draw yourself making these expressions.

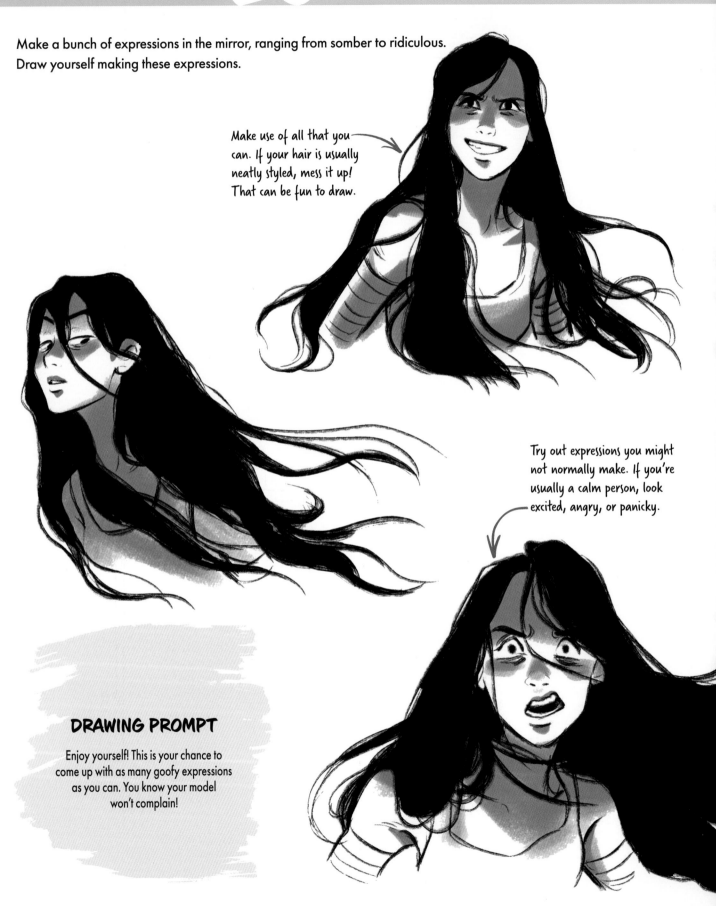

Make use of all that you can. If your hair is usually neatly styled, mess it up! That can be fun to draw.

Try out expressions you might not normally make. If you're usually a calm person, look excited, angry, or panicky.

DRAWING PROMPT

Enjoy yourself! This is your chance to come up with as many goofy expressions as you can. You know your model won't complain!

EXERCISE 27

Draw facial expressions where mood and emotions play a big part.

It's been said that most of our ability to communicate is based on nonverbal cues. This means that even without speaking, we are able to convey a lot of information. If you ask someone what time the train is due to arrive and they shrug, you know immediately that means they don't know. If a person is talking excitedly about something and you see a listener making a dismissive wave of their hand, you know that means they are not interested in what the other person is saying. If that person holds up a hand and taps their thumb and fingers together rapidly, mimicking a moving mouth, you know they are saying they think the other person talks too much. There is no end to the ways we can communicate nonverbally.

Consider this situation: You are with a friend and her phone rings. She picks it up and her eyes get very wide. She's just heard something that has caught her attention and possibly surprised her. She then starts tapping her pockets and looking in her purse anxiously. Looking to you, she holds up her hand in a mime of writing something. She's saying she needs a pen or a pencil. You hand her a pencil, and she begins circling dates in her pocket calendar. She circles one date in particular three times and then draws a star beside it and adds two exclamation points. Even without saying a word, your friend has conveyed quite a story to you, or at least the beginning of one.

Try out expressions you might not normally make. If you're usually a calm person, look excited, angry, or panicky.

DRAWING PROMPTS

Now confine the idea above to facial expressions alone. How much of a story can you convey using only your characters' faces? Here are some scenarios to help you out:

- Just touched gross, wet dishwater food

- When your crush responds to you

- Listening to your favorite song

- Sobbing at a movie

- Trying not to laugh

- Observing something that causes secondhand embarrassment

- Daydreaming

- Arguing passionately

- Giggling uncontrollably

EXERCISE 28

Choose an animal and sketch an expression sheet for them.

PLEASED TO SEE YOU

CONTENT

DRAWING PROMPTS

Observe how your animal moves and study its face (animals also convey their personality through different expressions).

- How does your animal behave when they want to go outside?

- When they see you've come home after being away?

- When they realize it's time for a bath, or a trip to the vet?

- How does your animal respond when they see they're going to get a treat?

BEGGING FOR ATTENTION

WAITING FOR FOOD

PLAYFUL

RELAXED

EXERCISE 29

Draw a generally expressionless, stoic character. How do they display slight twinges of emotion? Sometimes the smallest change can transform them.

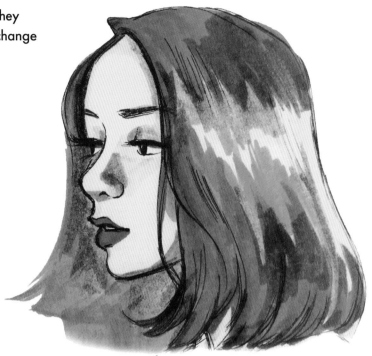

DRAWING PROMPTS

This is your chance to pause and study before putting pencil to paper or stylus to screen. Take your time. Look carefully and discover what you can see that might escape another person's attention. Recreate that in your character and watch for these things:

- Slight tilt of the head.

- Eye movement while head remains still.

- Finger slightly touching the nose, chin, or lips, indicating thought.

- Small shift in body posture.

- Biting the lips.

The eyes are the most expressive part of a person's face. Just by shifting their focus up, down, or to the side, you can give your character a plethora of varying emotions or indications of their hidden thoughts.

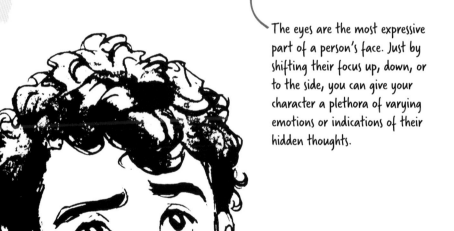

EXERCISE 30

Sketch a super-expressive, over-the-top character.

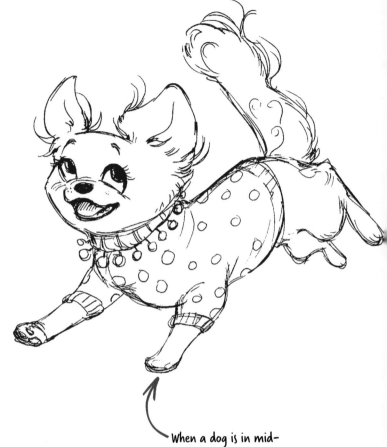

When a dog is in mid-stride, all four legs are off the ground.

DRAWING PROMPTS

Have you ever known or seen someone whose personality always seems exaggerated? Turn them into characters on the page. Examples include:

- A teacher who always moves his or her hands excitedly when talking.

- An authority figure who stomps around a lot.

- An easily amused friend who laughs at everything while throwing their head back and clutching their sides.

- An ill-tempered person who throws a tantrum over the smallest thing.

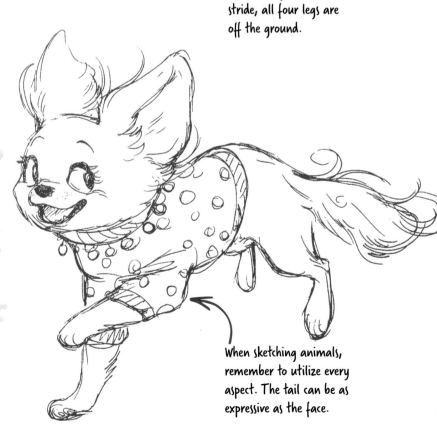

When sketching animals, remember to utilize every aspect. The tail can be as expressive as the face.

EXERCISE 31

Watch something funny. Observe the faces made by the characters in it and draw some comedic expressions inspired by what you see.

DRAWING PROMPTS

Consider things that have made you laugh out loud. Something you saw, something you heard, something you did . . . anything will do. Think of how you felt in that moment and inject some of yourself into that character.

Catch every aspect of humor you can. This guy has just seen something funny and is trying not to burst out laughing.

Humor can be shared. Your character may be turning to another person as if to say, "Did you just see that too?"

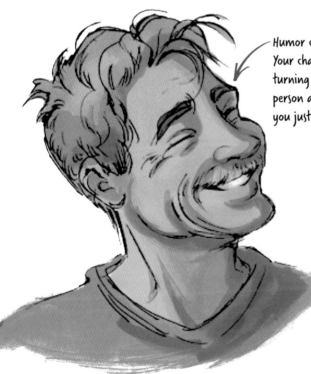

EXERCISE 32

Expand your thinking beyond your character alone to those around him or her.

We see differences in ages, sizes, expressions, and even grooming in the characters shown here that all help build distinct personalities and relationships.

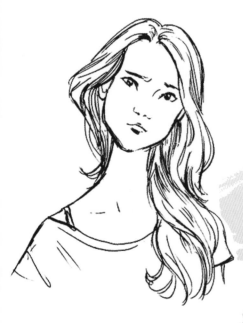

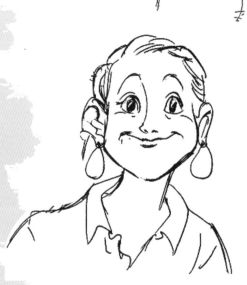

DRAWING PROMPTS

No character exists on their own. What fun would that be? Think of the people who may surround your main character. Consider a supporting cast, or just background characters coming and going only once.

- If your character is a screaming tyrant, those around may cringe, hide, or want to shout right back.

- Imagine a bus driver who opens the door with a smile, and how each passenger may respond to that.

- If your character is shy and tends to go unnoticed, all kinds of people may walk around him without reacting at all.

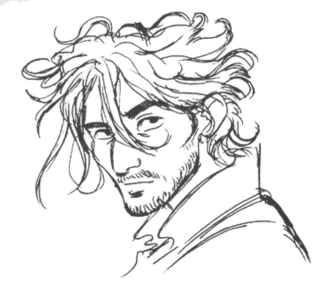

EXERCISE 33

Who is your character? Explore your character's identity through a study of expressions.

Arched eyebrows and wide eyes suggest that this character has seen something strange. However, the closed mouth could indicate that he's keeping his opinions to himself.

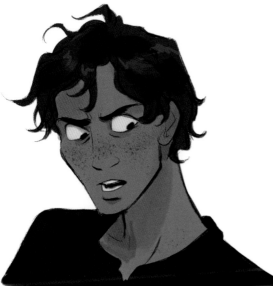

DRAWING PROMPTS

You can discover who your character is by really studying them. Draw your character as many times as you can on a few pages.

- How does your character react to a sudden surprise or bad news?

- Does your character grow quiet when pensive?

- Do they move around and voice their problems aloud?

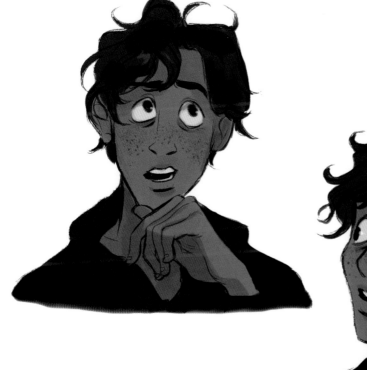

Wide eyes and an open mouth convey shock or surprise.

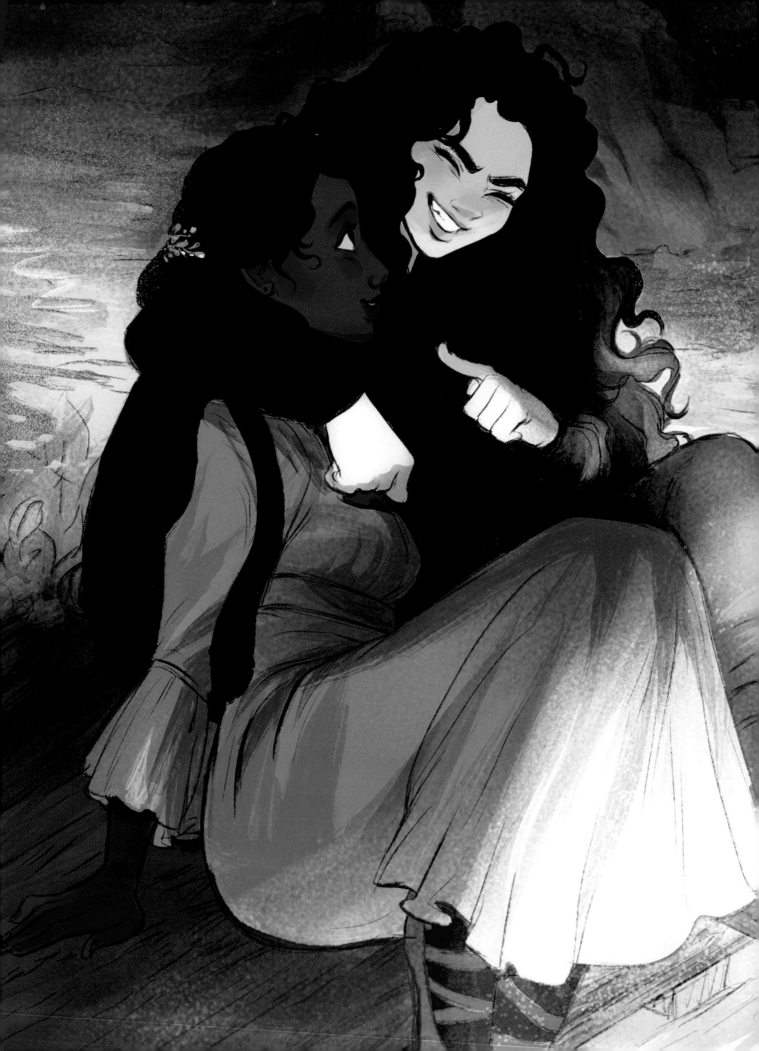

BODY LANGUAGE

We already know how much of our character can be conveyed through facial expressions. Well, the body has expressions, too. When your character is celebrating or dancing, the body language will be expressive and broad. If your character is concentrating, brooding, or plotting, the body language will be much more closed and contained. This is your chance to delve into all the ways your character's body language can convey many things, from attitude to emotions, to interaction with other characters. The body has an extensive and expressive language that varies from character to character. Let's delve into this and learn that language for your characters.

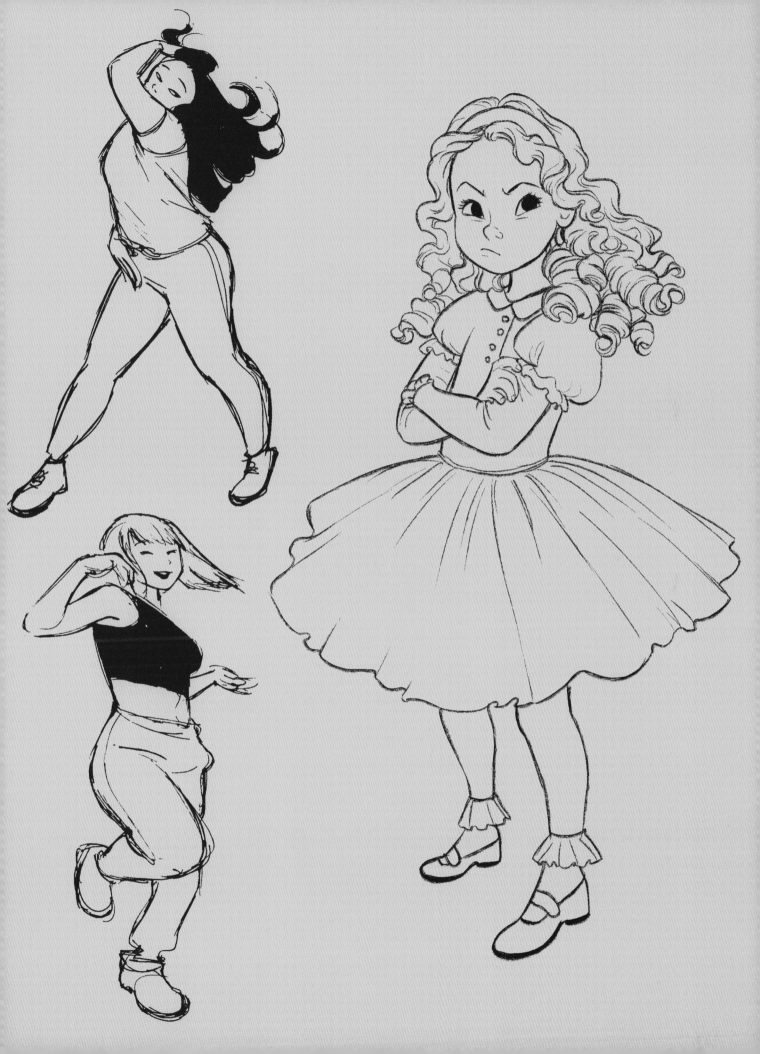

What makes a character's body language threatening or villainous? Create a villain who exudes menace through their body language.

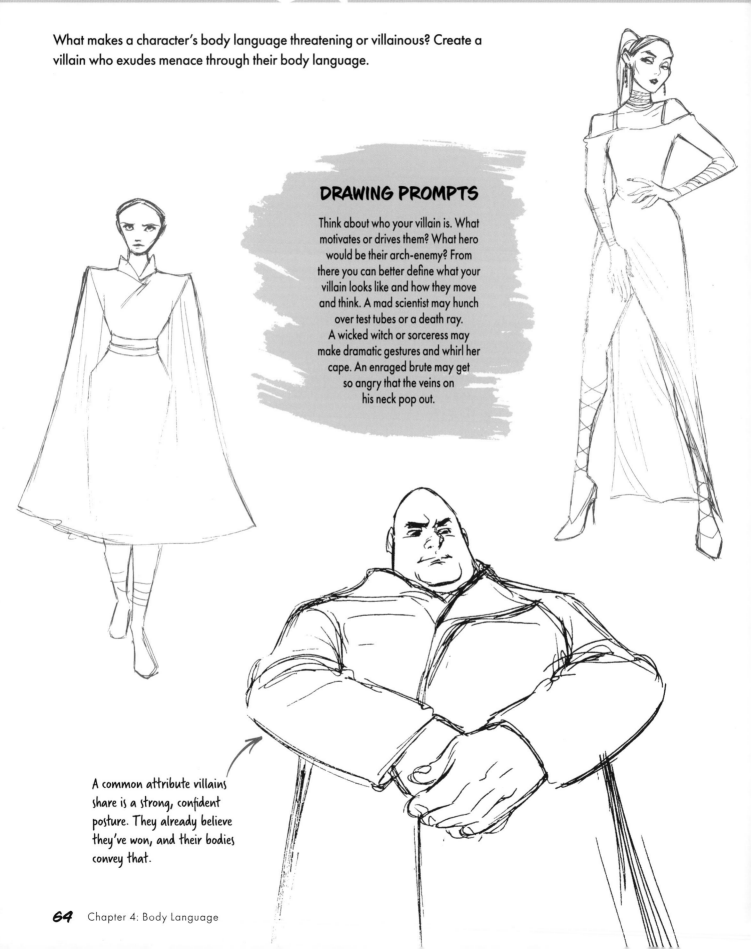

DRAWING PROMPTS

Think about who your villain is. What motivates or drives them? What hero would be their arch-enemy? From there you can better define what your villain looks like and how they move and think. A mad scientist may hunch over test tubes or a death ray. A wicked witch or sorceress may make dramatic gestures and whirl her cape. An enraged brute may get so angry that the veins on his neck pop out.

A common attribute villains share is a strong, confident posture. They already believe they've won, and their bodies convey that.

Create a character who embodies anxiety.

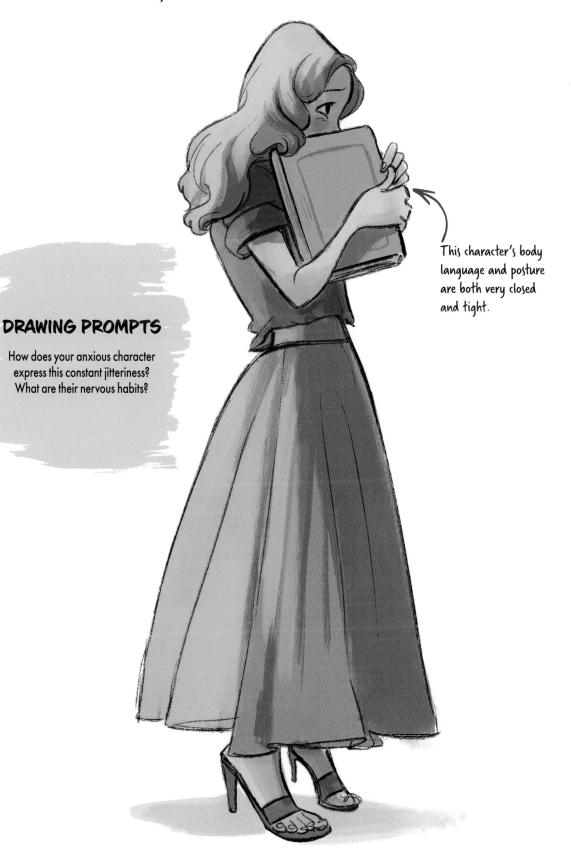

This character's body language and posture are both very closed and tight.

DRAWING PROMPTS

How does your anxious character express this constant jitteriness? What are their nervous habits?

EXERCISE 36

Create a haughty, pompous character.

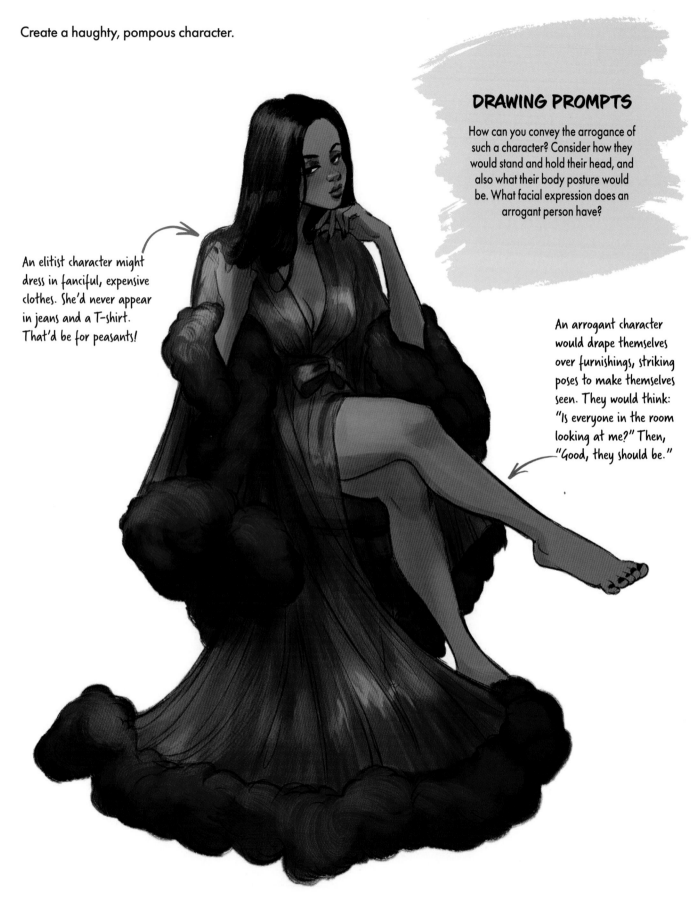

DRAWING PROMPTS

How can you convey the arrogance of such a character? Consider how they would stand and hold their head, and also what their body posture would be. What facial expression does an arrogant person have?

An elitist character might dress in fanciful, expensive clothes. She'd never appear in jeans and a T-shirt. That'd be for peasants!

An arrogant character would drape themselves over furnishings, striking poses to make themselves seen. They would think: "Is everyone in the room looking at me?" Then, "Good, they should be."

EXERCISE 37

Create a character whose body language totally contradicts their physique and presentation.

You wouldn't expect a small, young character to leap into the fray wielding a big sword. Combining these two contradictory elements can give your character real impact.

DRAWING PROMPTS

What characters can you come up with using this contradictory method?

Note this girl's strong, solid posture. She isn't fumbling with her weapon; she knows what she's doing. That seems to be quite a contradiction, right there!

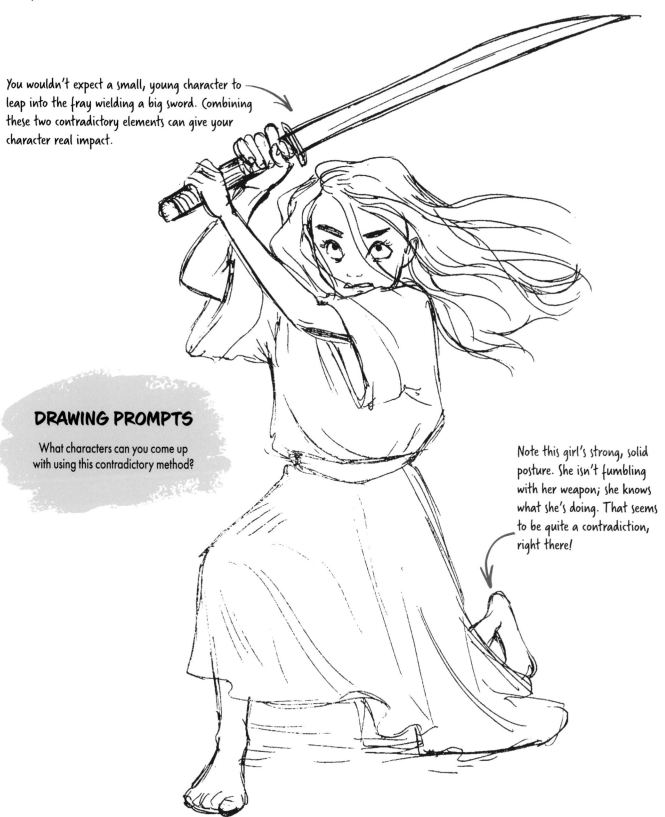

Draw 10 different ways to sit.

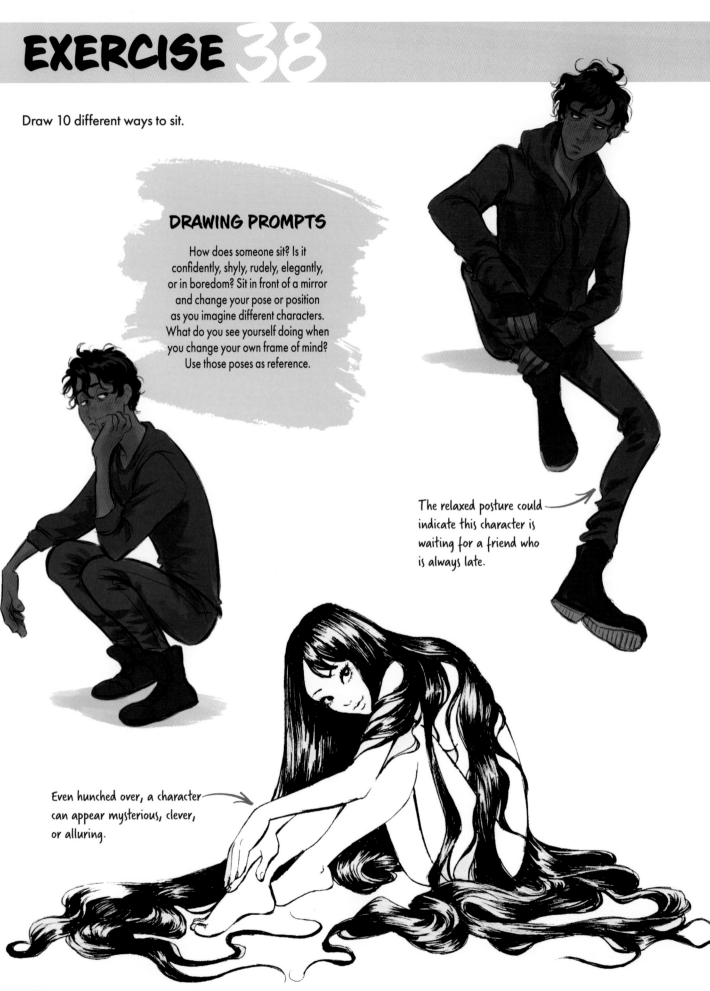

DRAWING PROMPTS

How does someone sit? Is it confidently, shyly, rudely, elegantly, or in boredom? Sit in front of a mirror and change your pose or position as you imagine different characters. What do you see yourself doing when you change your own frame of mind? Use those poses as reference.

The relaxed posture could indicate this character is waiting for a friend who is always late.

Even hunched over, a character can appear mysterious, clever, or alluring.

Draw 10 different ways of walking.

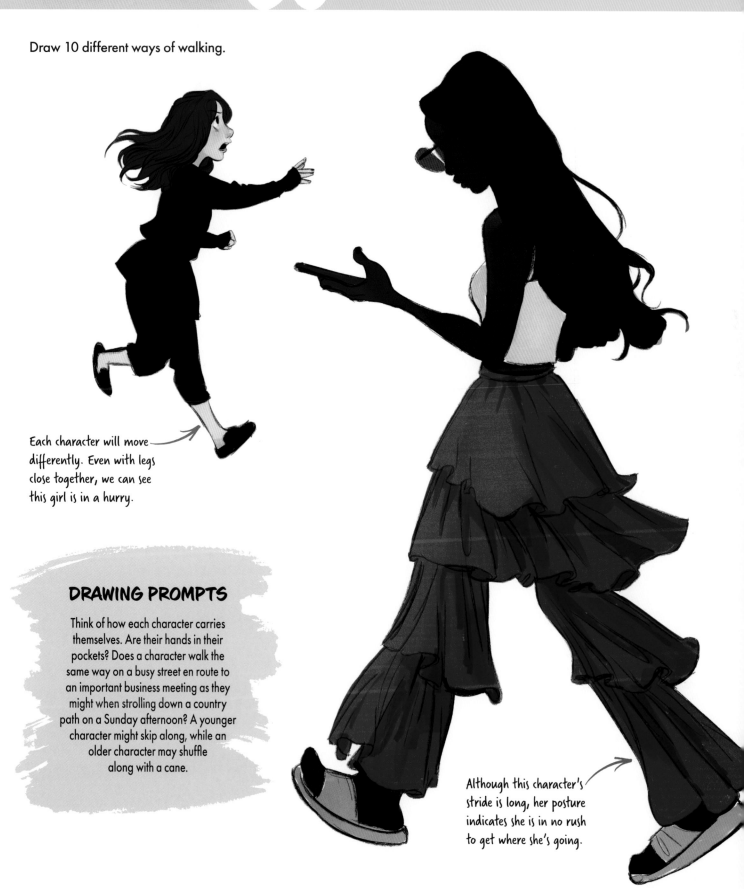

Each character will move differently. Even with legs close together, we can see this girl is in a hurry.

DRAWING PROMPTS

Think of how each character carries themselves. Are their hands in their pockets? Does a character walk the same way on a busy street en route to an important business meeting as they might when strolling down a country path on a Sunday afternoon? A younger character might skip along, while an older character may shuffle along with a cane.

Although this character's stride is long, her posture indicates she is in no rush to get where she's going.

Sketch some poses that convey exhaustion or energy.

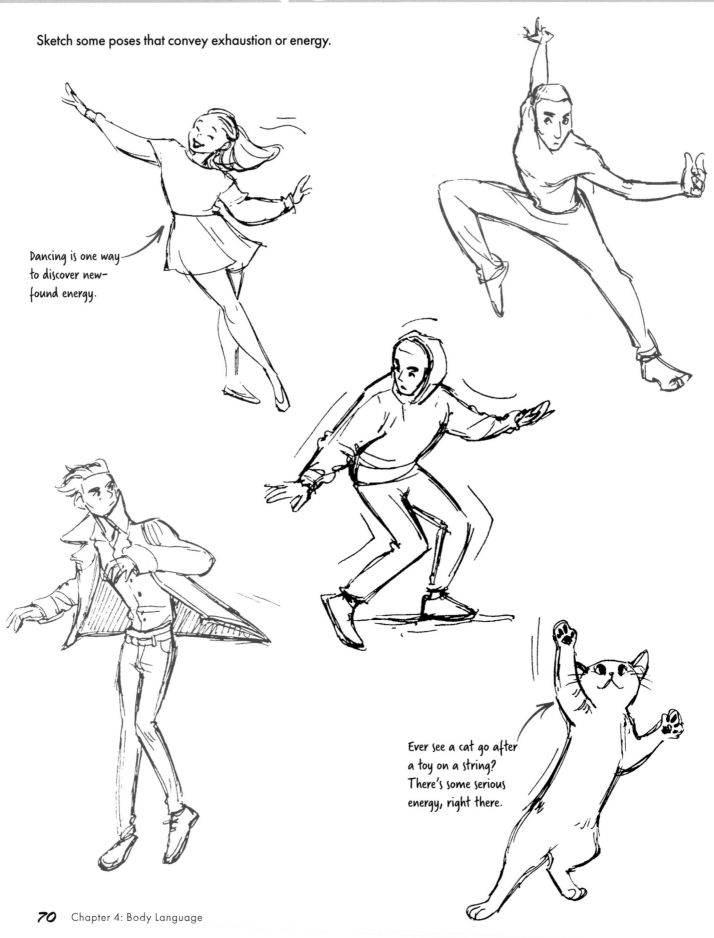

Dancing is one way to discover new-found energy.

Ever see a cat go after a toy on a string? There's some serious energy, right there.

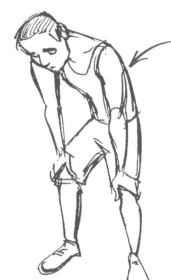

Consider that heavy emotions can make a person as exhausted as a runner who's just finished a track meet.

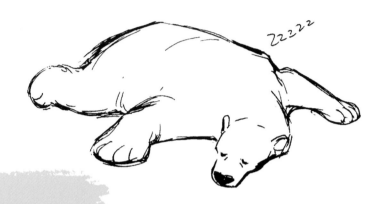

Zzzzz

DRAWING PROMPTS

When sketching poses such as these, think first about what might fill a person with energy or leave them exhausted. Sketch from your own experiences as well as what you've seen in others. Many hours of hard work can leave you exhausted, but so can laughing hard for a long time. An exciting event or occasion may fill you with energy, but so can the anticipation leading up to that event. What's exciting for you? What's exhausting?

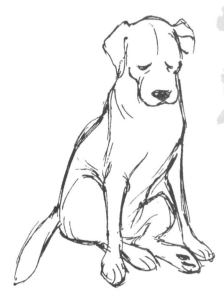

Exhaustion need not always be negative. This lad may have collapsed in the grass after a full day of joyful playing and adventures.

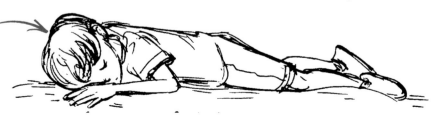

EXERCISE 41

Sketch a little kid or baby playing, throwing a tantrum, running around, and doing the kinetic things little kids do.

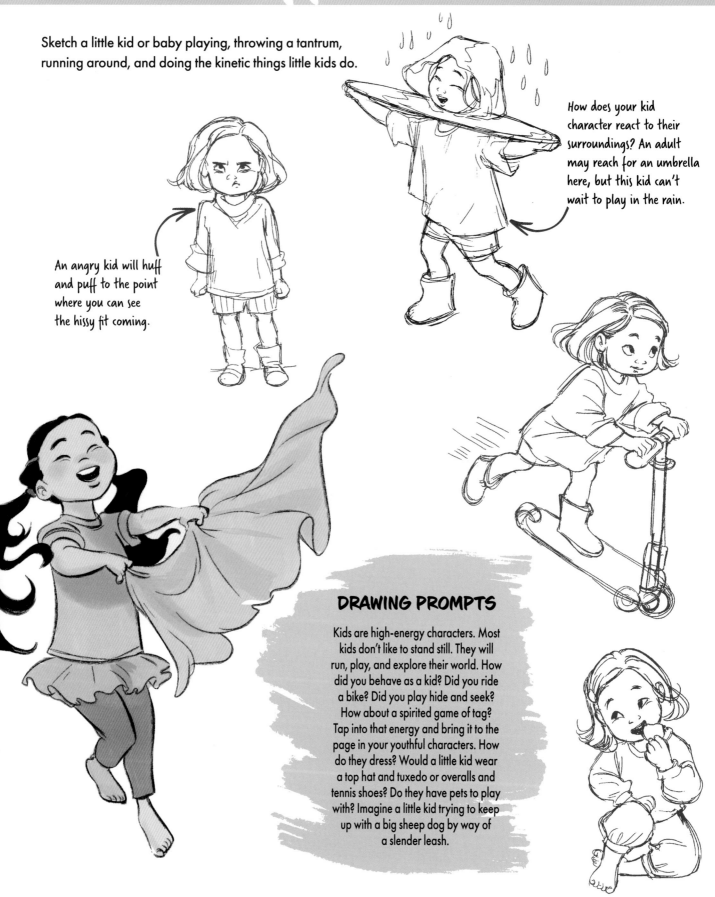

How does your kid character react to their surroundings? An adult may reach for an umbrella here, but this kid can't wait to play in the rain.

An angry kid will huff and puff to the point where you can see the hissy fit coming.

DRAWING PROMPTS

Kids are high-energy characters. Most kids don't like to stand still. They will run, play, and explore their world. How did you behave as a kid? Did you ride a bike? Did you play hide and seek? How about a spirited game of tag? Tap into that energy and bring it to the page in your youthful characters. How do they dress? Would a little kid wear a top hat and tuxedo or overalls and tennis shoes? Do they have pets to play with? Imagine a little kid trying to keep up with a big sheep dog by way of a slender leash.

EXERCISE 42

Sketch a character who wears a mask. How do they express themselves through body language alone?

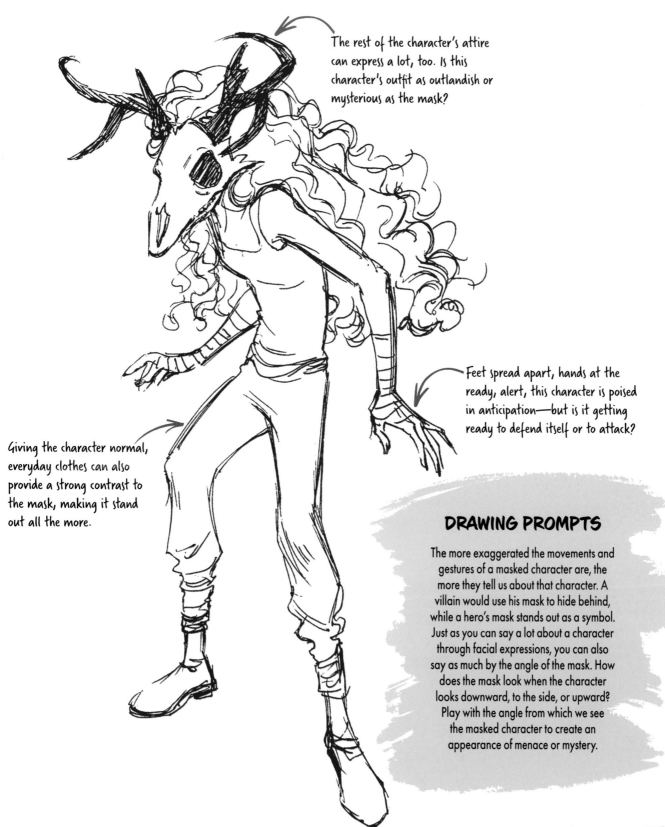

The rest of the character's attire can express a lot, too. Is this character's outfit as outlandish or mysterious as the mask?

Feet spread apart, hands at the ready, alert, this character is poised in anticipation—but is it getting ready to defend itself or to attack?

Giving the character normal, everyday clothes can also provide a strong contrast to the mask, making it stand out all the more.

DRAWING PROMPTS

The more exaggerated the movements and gestures of a masked character are, the more they tell us about that character. A villain would use his mask to hide behind, while a hero's mask stands out as a symbol. Just as you can say a lot about a character through facial expressions, you can also say as much by the angle of the mask. How does the mask look when the character looks downward, to the side, or upward? Play with the angle from which we see the masked character to create an appearance of menace or mystery.

EXERCISE 43

Sketch characters in motion.

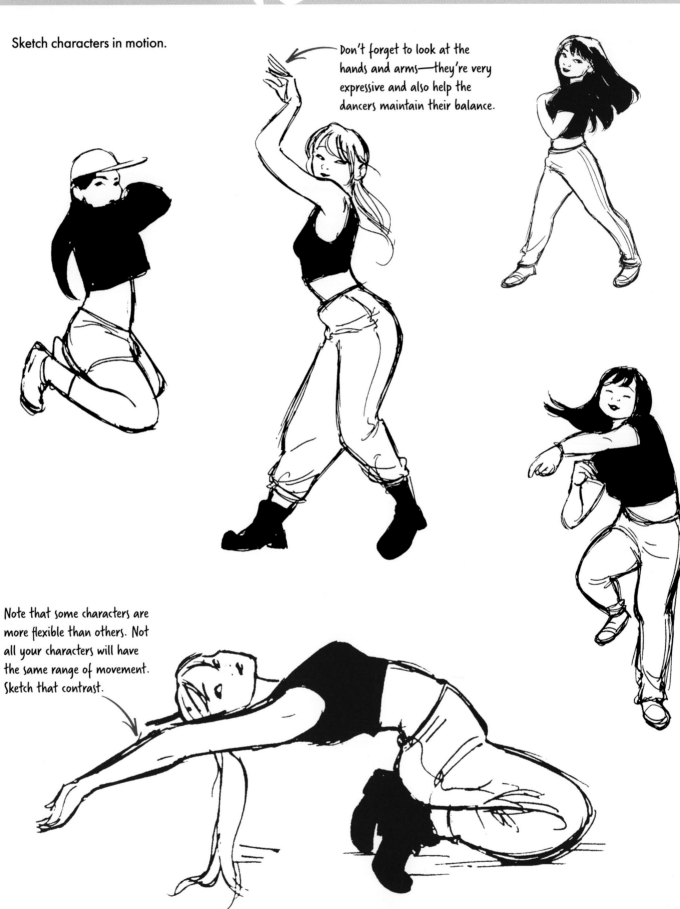

Don't forget to look at the hands and arms—they're very expressive and also help the dancers maintain their balance.

Note that some characters are more flexible than others. Not all your characters will have the same range of movement. Sketch that contrast.

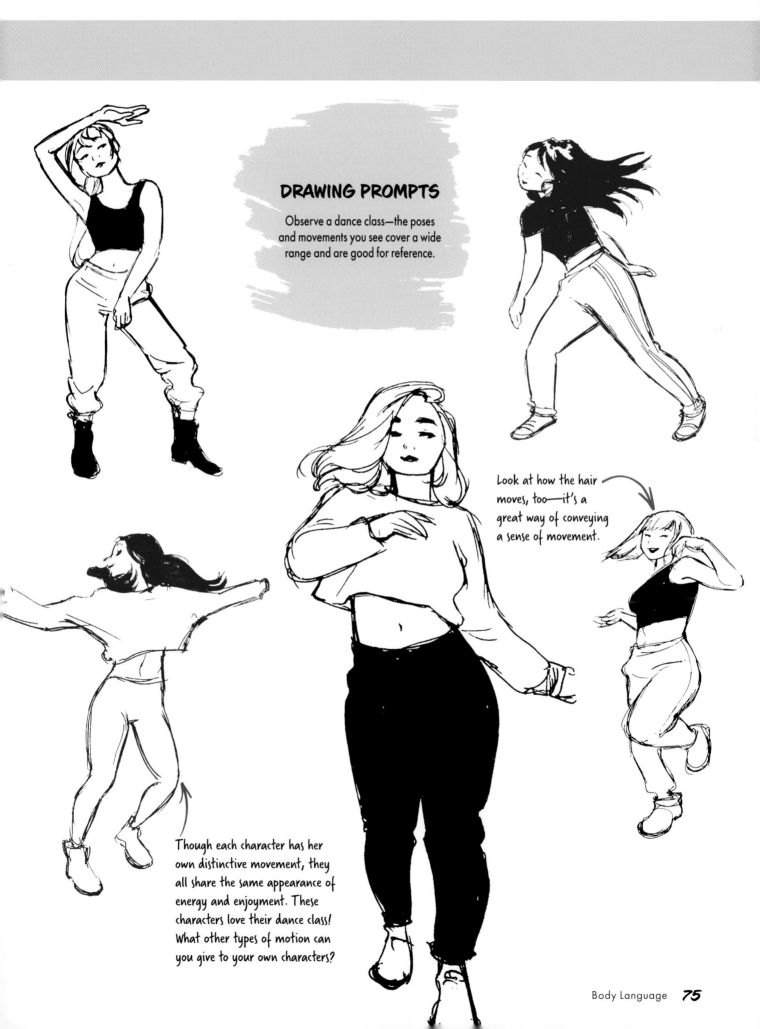

DRAWING PROMPTS

Observe a dance class—the poses and movements you see cover a wide range and are good for reference.

Look at how the hair moves, too—it's a great way of conveying a sense of movement.

Though each character has her own distinctive movement, they all share the same appearance of energy and enjoyment. These characters love their dance class! What other types of motion can you give to your own characters?

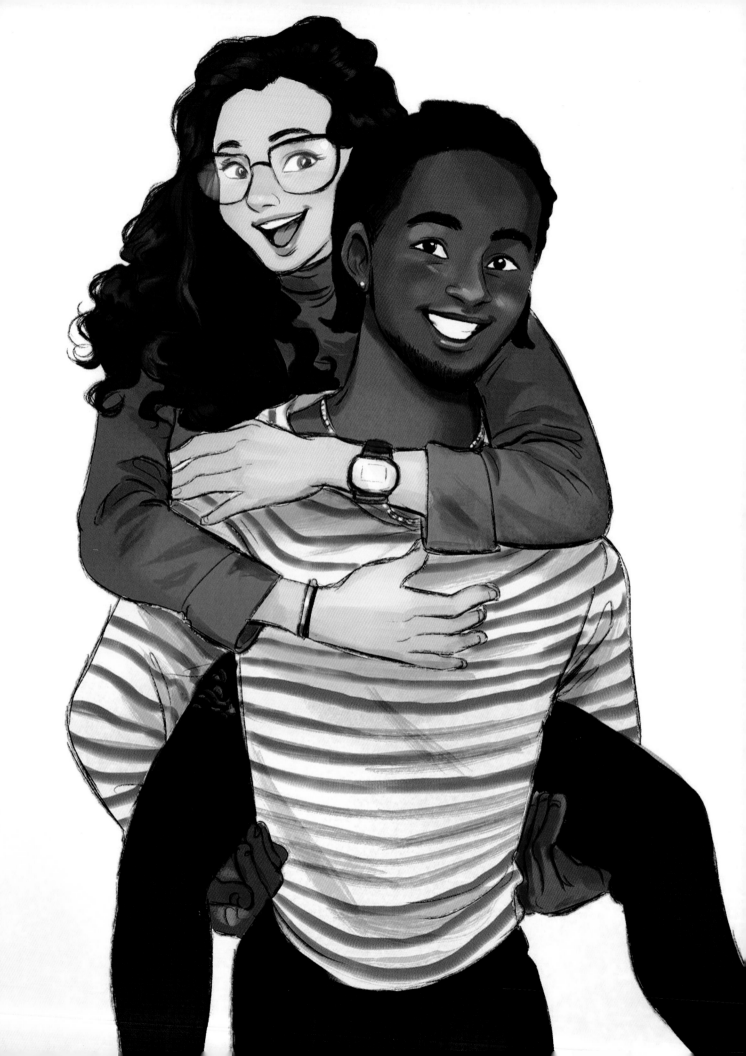

CHARACTER INTERACTIONS

How do we illustrate a compelling relationship between characters—be it friendship, romance, hatred, or rivalry? Imagine two characters standing next to each other. If they are friends, they may stand close or even make contact with one another. But what if they are enemies? Would they stand close, or work to keep their distance? If they did move closer, would they be preparing for a big argument or even braced for a physical battle?

If the characters are a romantic couple, one may scoop the other up into their arms, or lie side by side in a field of daffodils. Strangers wanting to get to know each other may approach cautiously, or not approach at all as they eye one another warily. What if one is an expansive extrovert ready to greet the other, while the other is a timid introvert, shrinking away from loud encounters? Just as there is no end to ideas for character interaction, so there are no limits to what you can create for them.

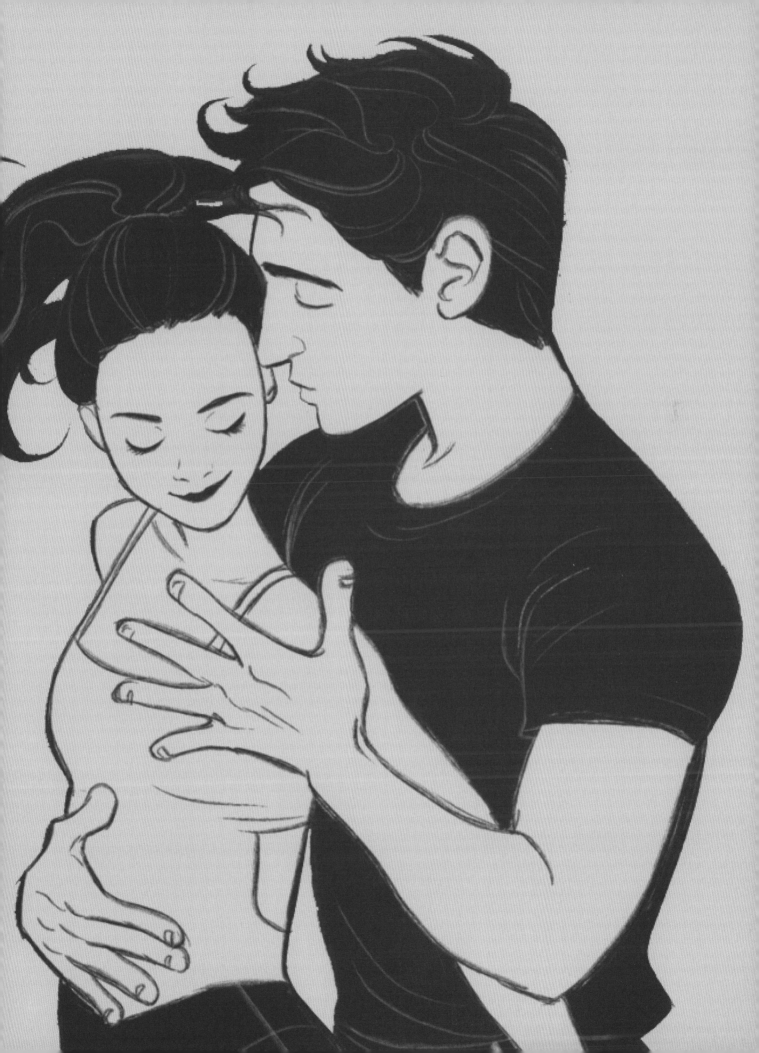

EXERCISE 44

Draw two characters who are diametrically opposed—in other words, they are opposites of one another.

DRAWING PROMPTS

What are the conflicting belief systems of your two characters? What are their body types and clothing choices? How do they express themselves, and do their differences bring them together or push them apart? Keep in mind that while the characters can be different in general appearance (one could be tall and the other short, one bulky and the other slender, or one brightly colored and the other in dark attire), their expressions and body language can be opposites, too. A character with a beaming smile may be beside a snarling grump. A character who hops about and waves his arms while he talks may be trying to communicate with someone with crossed arms scrunched in a corner. What can you imagine for your characters?

The height difference between these characters is emphasized, as the much taller character has to hunch over to address the shorter one.

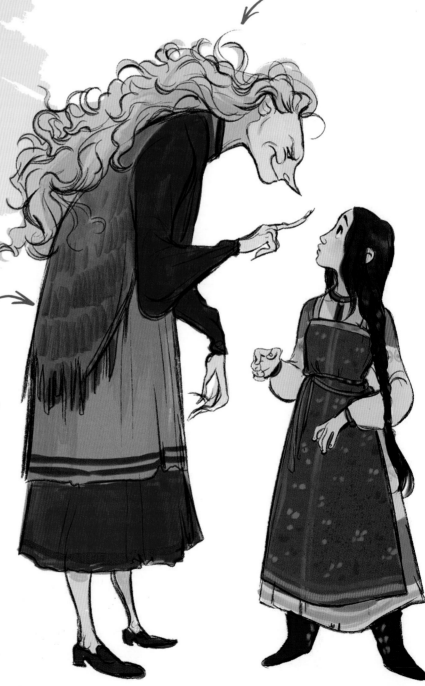

Posture and expression come into play again to show the differences between these two characters. The gray-haired woman—maybe a witch! Who knows?—looms over the little girl with a snide expression. Conversely, the small girl looks up with concern.

EXERCISE 45

Illustrate different kinds of relationships.

Eyes locked together—
you can tell these two
are the best of friends!

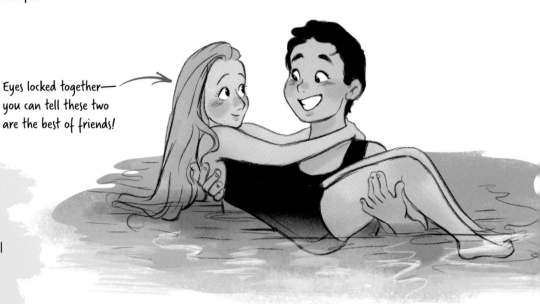

DRAWING PROMPTS

How would body language and facial
expression apply to these character
relationships? Here are some
examples to help you out:

Tender • Spiteful • Bitter rivals
• Slight annoyance
• Best friends, so close they know
each other's deepest secrets

Playtime! This character's
expression tells us she's messing
around and having fun—but
she's not losing her grip on her
best friend!

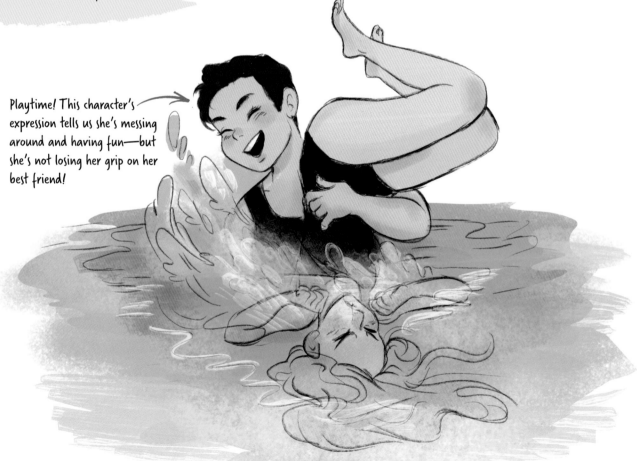

EXERCISE 46

Draw a character who is intimidating another character.

DRAWING PROMPTS

How do the characters display this interaction? Take a look at this lizard—that can be intimidating in itself!—and see how movement and posture express his mood and presence. How might you use those approaches for your own character? A lizard, gorilla, or large man can certainly be intimidating. But can a small grandmother or tiny animal be intimidating too? You bet they can! Apply intimidating traits to a variety of different characters and see what you can create.

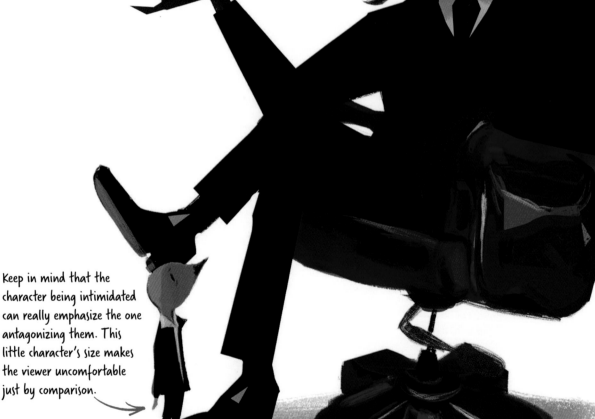

Keep in mind that the character being intimidated can really emphasize the one antagonizing them. This little character's size makes the viewer uncomfortable just by comparison.

EXERCISE 47

Draw a few different types of hugs.

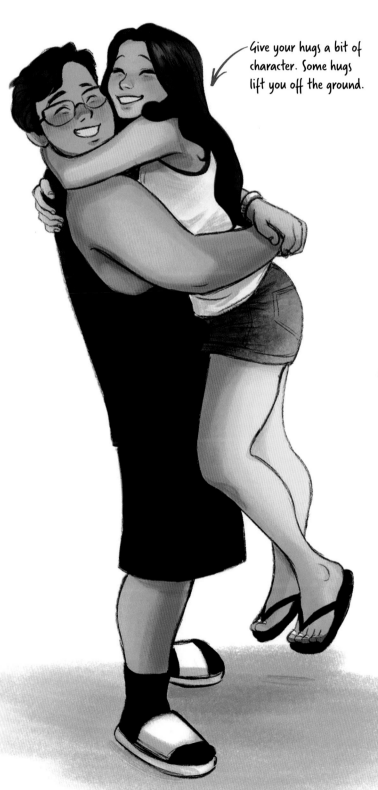

Give your hugs a bit of character. Some hugs lift you off the ground.

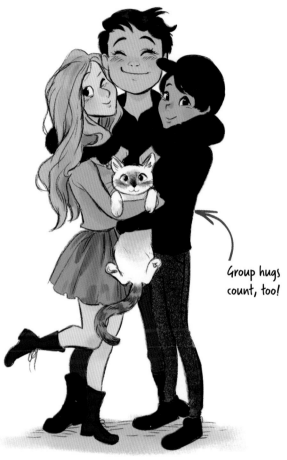

Group hugs count, too!

DRAWING PROMPTS

What kind of relationship and mood is conveyed through each hug? Here are some examples to help you out:

- A bear hug.
- An awkward hug.
- A dramatic reunion hug.
- A comforting hug.
- A hug from behind.
- Hugging a relative you don't want to hug.
- Hugging your secret crush.
- A hug between best buddies.
- A guy hug.

Draw characters with a large size difference.

Eye contact shows the characters' closeness.

DRAWING PROMPTS

How do the characters interact with one another? It could be a child and parent, an elf and an orc, a fairy and an ogre, a cat and a human, a teacher and a student, or anything else you can think of!

Remember that size difference doesn't always have to be intimidating. As you can see from these examples, sometimes the duo can be joyful.

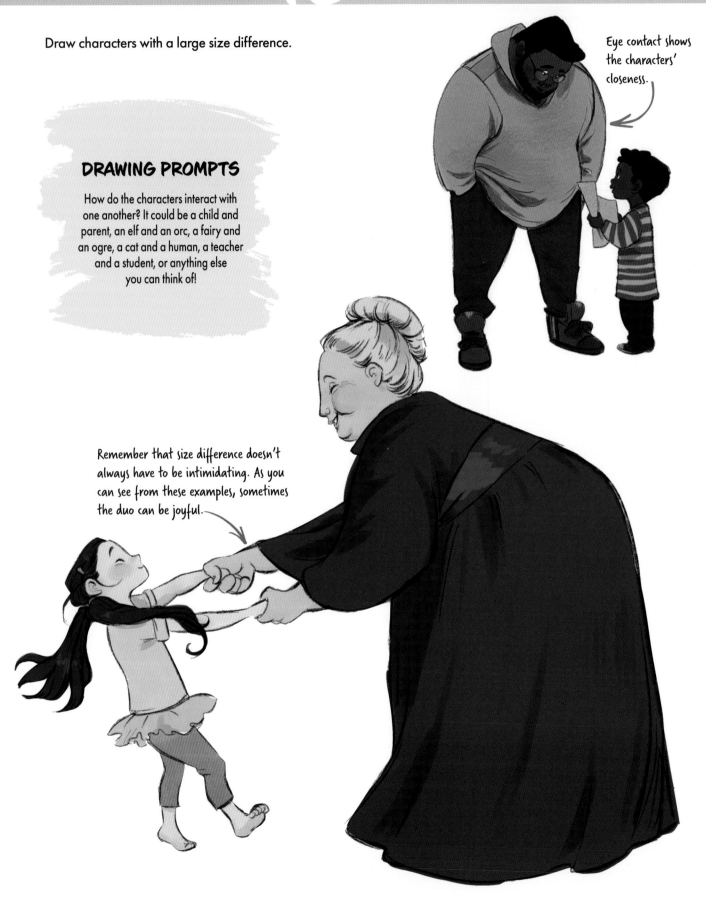

Draw a group of friends.

Give each friend their own posture and personality.

DRAWING PROMPTS

Friends don't always behave as they do in photographs when crowding together arm-in-arm to smile for the camera. Draw the friends walking together, but moving in different ways and showing their different strides. We love some friends even though they drive us crazy. Draw a member of the group being a bit annoying. Some friends grow very close. Draw close friends sharing secrets together. Other friends love to celebrate together. How would your group of friends look at a party, while dancing, or lighting sparklers on a national vacation?

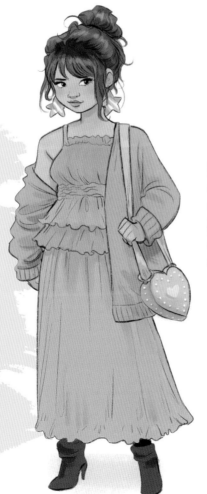

Friends can look very different from one another—have fun with hairstyles, dress sense, and attitude!

EXERCISE 50

Sketch characters debating or arguing. Is one cool and collected, the other impassioned and indignant?

People often use their hands when they are arguing or making a point strongly.

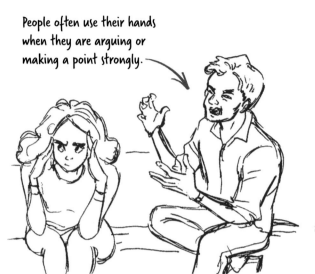

DRAWING PROMPTS

As you design your arguing characters, it helps to think through what they are arguing about. If a mother is scolding her child for leaving the screen door open, she is not going to seem as upset as a superhero arguing with his sidekick about their failure to disarm the villain's doomsday device. Think of who your characters are in relation to the situation being contested. This will help immensely in deciding poses and expressions.

A person who knows they're in the wrong may grow angrily defensive.

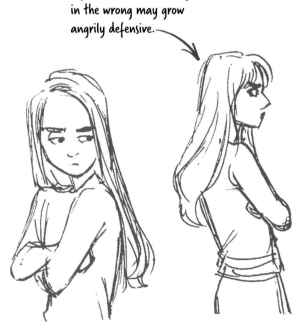

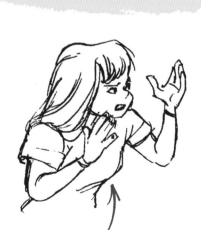

Sometimes the person who feels in the right will become animated and insistent.

EXERCISE 51

Draw a pair of best friends.

DRAWING PROMPTS

The words 'best friends' can have many meanings. A dog is considered man's best friend. Perhaps your character is someone with his dog. Perhaps the best friends are two boys, two girls, or a boy and a girl. A grandparent can be the best friend to a grandchild. Best friends could be two characters who are very much alike, or have almost nothing visually in common. What do you think of when you think of best friends?

Here, these two characters tell us they're best friends by their poses, interaction, and expressions.

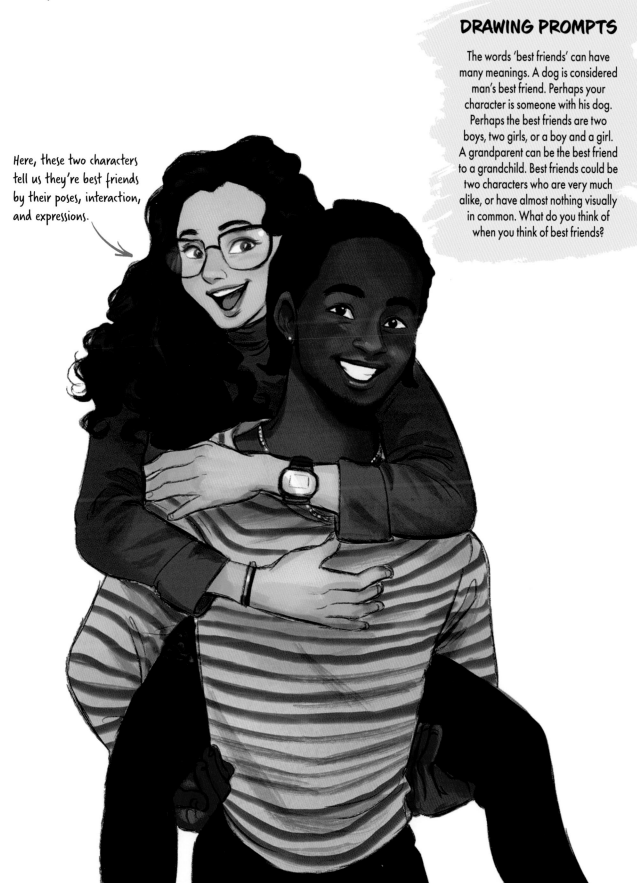

EXERCISE 52

Sketch a character fighting some kind of monster.

DRAWING PROMPTS

Here we see a looming, eerie monster ready to descend on the hero. But remember that, like any other characters, monsters can come in all shapes and sizes. Perhaps your monster is a werewolf fighting a beast-hunter of a similar size. Maybe it's a tiny monster who slips through cracks in the wall or emerges from a forbidden book. What comes to mind when you hear the word "monster"? Does it live under a bridge, or under your bed? Is it covered in fur or scales, or strange parts sewn together? It could rise from a swamp, covered in fungus and slime. What will your monster be?

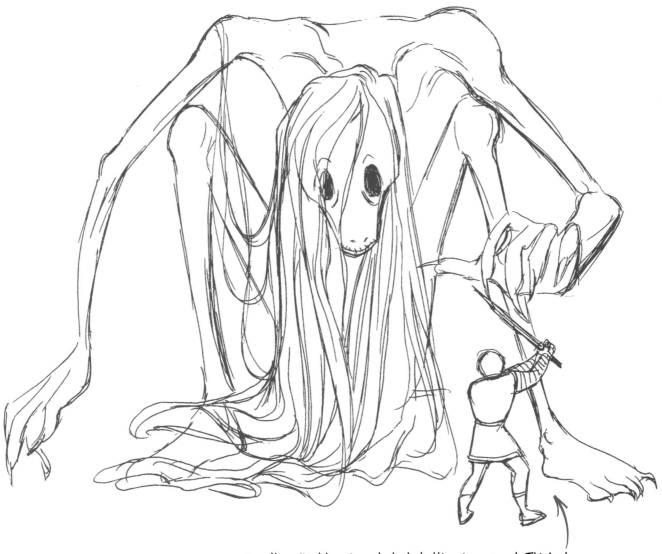

Here, the valiant hero is ready to do battle using a sword. Think of other ways the confrontation might go: for example, your character might try to outrun the monster, or trap it with a magic spell.

Draw a character interacting with an animal.

Follow the owner's gaze—he's watching his cat intently to see how it reacts. Every pet owner will recognize this kind of interaction!

DRAWING PROMPTS

Is this animal a pet? Is it a mighty elephant giving a ride to someone who lives in the jungle? Is your character admiring a pretty fish through the glass of a fish bowl? Is your character covering his ears as a crowing cockerel noisily wakes him up from just outside the window? There are no limits or restrictions to what you choose.

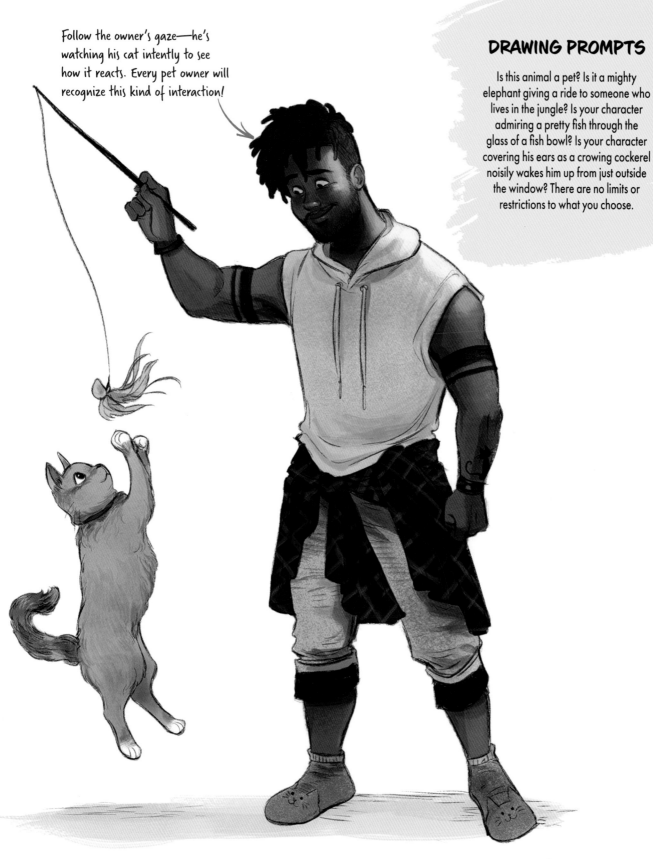

Draw someone taking care of a child.

The baby's arms are thrown out to the side—he trusts his dad completely.

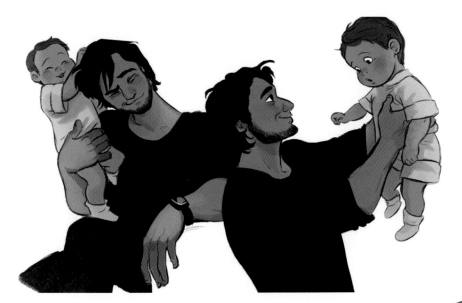

Eyes closed, heads touching, the dad's arms tenderly cradling his little boy—the bond between them is unmistakable.

DRAWING PROMPTS

Is the child you imagine a baby? A toddler? A teenager? A character may take care of a child by feeding with a bottle, reading a story from a big book, or showing a pre-teen how to throw a curve ball. Who is taking care of the child you'll draw, and how are they doing it?

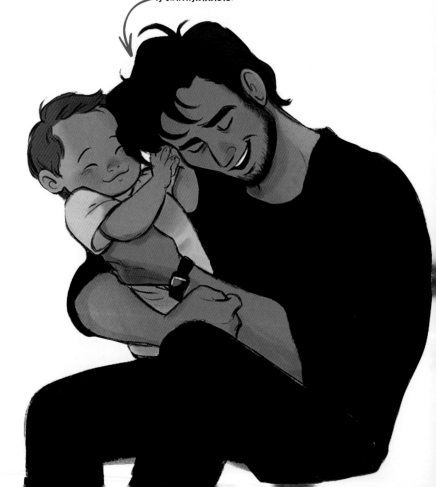

Create a cast of characters.

DRAWING PROMPTS

Who are your cast of characters? A family? Classmates? A sports team? A group of heroes or adventurers? In what ways are they different? In what ways can you tell they belong together? Think about similarities or differences in facial features, regular clothing, belongings, or uniform.

This group shares a similar style of dress. Even so, notice how each character has their own personal take on that look.

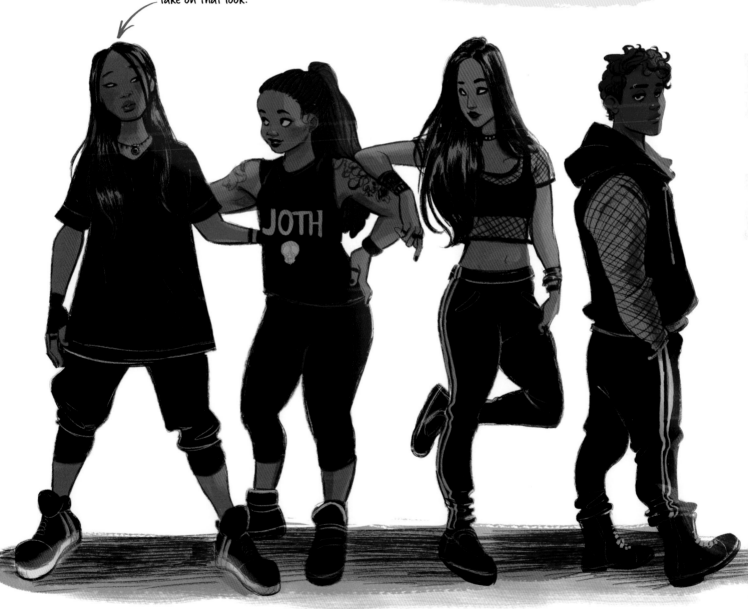

EXERCISE 56

Tell a story using only two characters.

DRAWING PROMPTS

Who are the two characters to each other? Are they friends? Family? Teammates? Enemies? Magical creatures? Show who they are using facial features, expressions, clothing, and posture. Let's see just who they are with one drawing.

A classic pairing is that of two people in love. Do you imagine this particular duo as two people who are born to be together or as an "opposites-attract" couple who have drastically different appearances?

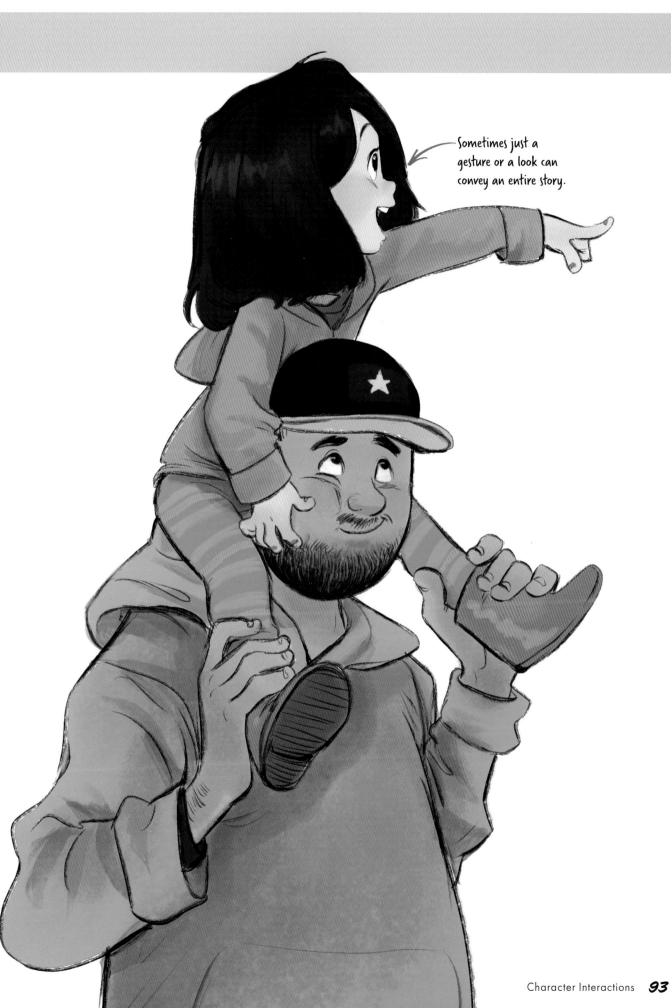

Sometimes just a gesture or a look can convey an entire story.

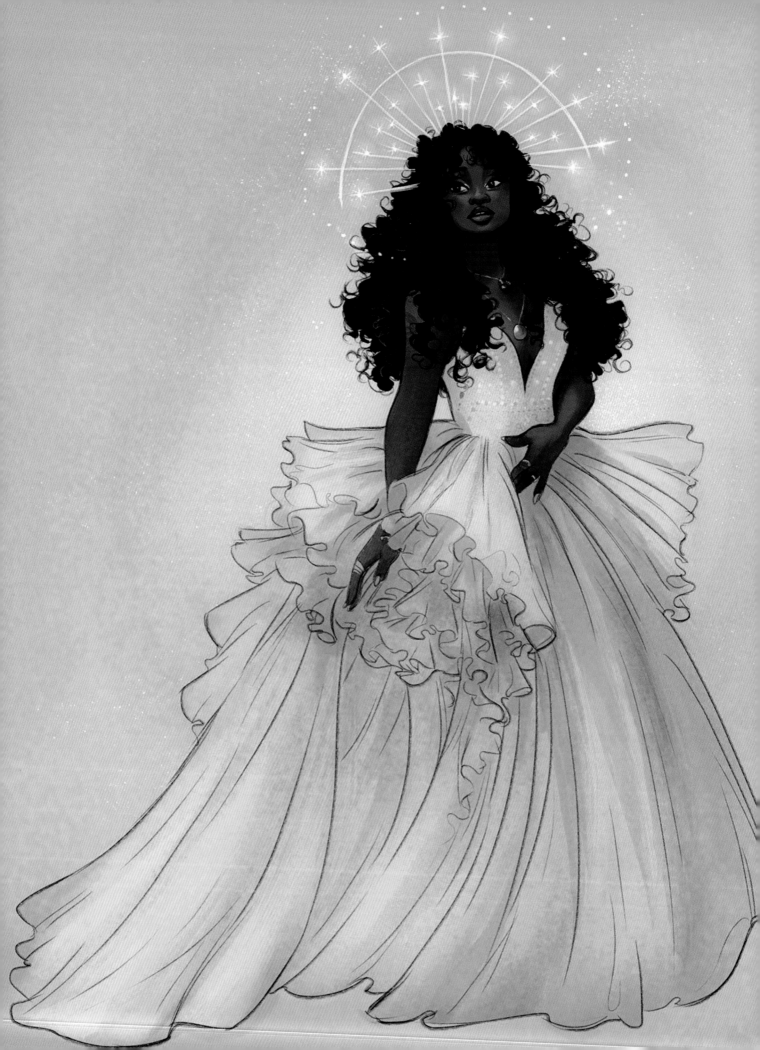

COSTUME
AND PROPS

How we dress our characters and what we give them to use and for interacting with others are essential in telling their stories. Without costumes and props, we have nothing but a cast of mannequins standing around all day doing nothing in an empty void. Costume can be more than fancy dress, superhero tights, suits, armor, or period attire. A grandmother's apron can be part of her costume. A first baseman's baseball mitt can be part of his costume, too. Costume does not always mean a disguise. For your characters, it means how you choose to dress them. A character's costume can tell you a lot about who they are and serve as an introduction to their attitudes, behavior, and even motives, before we see them do or say anything.

Props are equally important. A banker's fountain pen can be a prop. A baker's rolling pin or a teacher's dry erase board are all props. A prop is anything that your character can carry, make use of, or stand next to. A desk, a sofa, or a potted plant can be just as much a prop as a magic wand, a race car, or a robot tiger. When you bring your characters to mind, what are they wearing and what are they doing or about to do? You can see how costume and props both play an important role in your character's development right from the start.

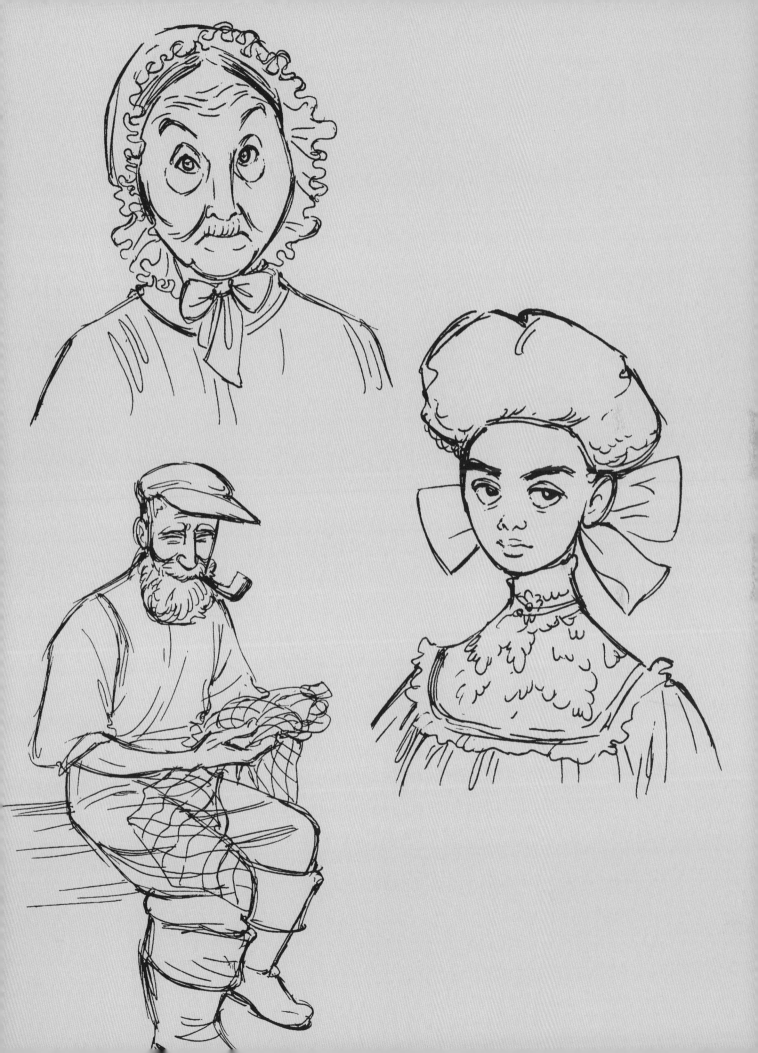

EXERCISE 57

Build a reference library.

What esthetics and designs interest you? Rococo? Gothic? Japanese street fashion? It's a good idea to keep a collection of inspiring photos.

 If you have a character who is a farm boy, do a search for just that. Save images of real young farmers. How will your farmer dress? Do you want him in bib overalls, coveralls, worn jeans and a plaid shirt, or big rubber boots? Will he wear a straw hat or a cowboy hat, or let his unkempt hair blow in the breeze?

 Once you've got images for your character (or characters), it is best to concentrate on things you have trouble drawing. We all have one or two things that we just can't quite get down on the page at first try (maybe more than one or two!). The more expansive your library, the better prepared you are to improve your drawing abilities.

 From there, the sky's the limit. If your characters live in a bustling city, you get to create images of buildings, bridges, streets, alleys, and cabs. If your sparkling fairy has adventures in an enchanted forest, you can begin collecting references for trees, forests, dirt trails, cottages, bears, squirrels, and birds. You don't want your amazing characters to be left to wander around an empty void. The sooner you begin your personal image library, the more fun you can have!

DRAWING PROMPTS

Say you have a main character who is a savvy businesswoman. Does she wear her hair back in a tight bun that complements her stylish glasses? You'll want to research business fashions and accessories. Does your character wear a blazer and crisp skirt, or a striking pants suit with flare-bottom slacks? Will she carry a briefcase, or have all the information she needs at her fingertips on a Blackberry? The more you find, the more you expand your library and the more information you have to build your characters.
Even if you find images that may not apply directly to your specific character, they may inspire something in your imagination that will.

EXERCISE 58

What's your favorite historical period? Collect reference material for it and use this to create character designs.

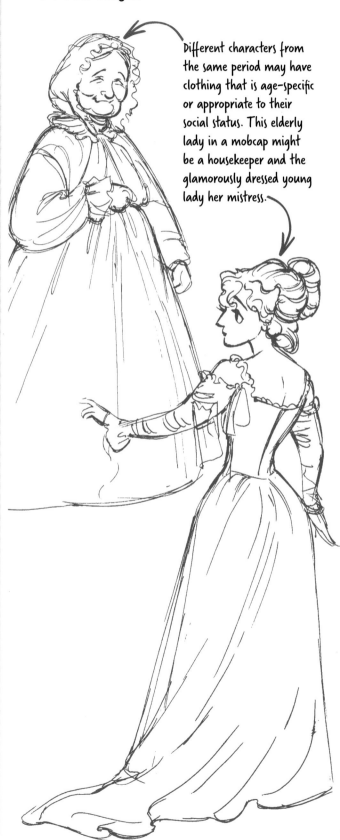

Different characters from the same period may have clothing that is age-specific or appropriate to their social status. This elderly lady in a mobcap might be a housekeeper and the glamorously dressed young lady her mistress.

DRAWING PROMPTS

Use this opportunity to explore your favorite time period when building your characters. Do some research! In looking for accurate representations of clothing, culture, and surroundings, you may discover things about that time in history you didn't know before. All of history is yours to peruse! You may have citizens of the Roman Empire watching centurions march by. It could be the 1960s and the dawn of the space race, as scientists, mechanical engineers, and military personnel scurry about to reach the stars. You could have a cluster of cavemen hunting down a wooly mammoth or discovering fire. Take a trip through time via your imagination.

Use your characters' position within the group you're sketching as a starting point for their physical appearance, costumes, and accessories. Who is the family patriarch here? The artistic eldest child? The doting mother?

What work was done by the people of this time period? Were there farmers, thatchers, or blacksmiths? Perhaps they were fishermen, like this fellow?

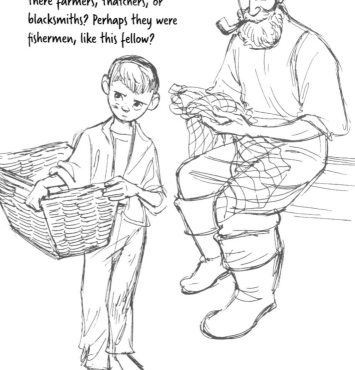

Hats and hairdos can speak volumes about a character's age and social status— flowing ringlets for a young child, an elaborate wig for a young lady about town, or a mobcap for a humble servant.

Design characters with very specific costumes.

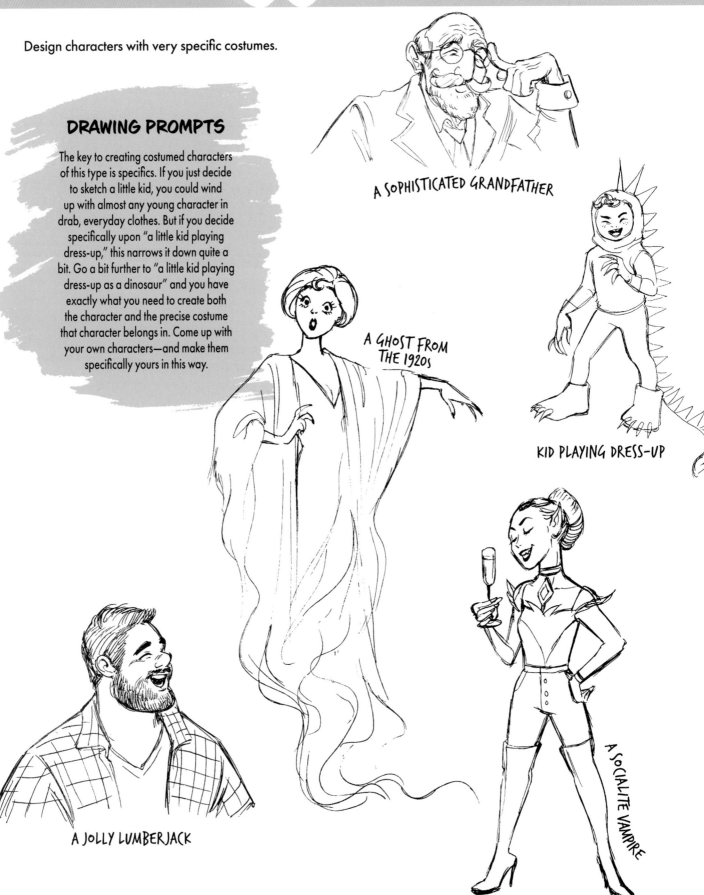

DRAWING PROMPTS

The key to creating costumed characters of this type is specifics. If you just decide to sketch a little kid, you could wind up with almost any young character in drab, everyday clothes. But if you decide specifically upon "a little kid playing dress-up," this narrows it down quite a bit. Go a bit further to "a little kid playing dress-up as a dinosaur" and you have exactly what you need to create both the character and the precise costume that character belongs in. Come up with your own characters—and make them specifically yours in this way.

A SOPHISTICATED GRANDFATHER

KID PLAYING DRESS-UP

A GHOST FROM THE 1920s

A SOCIALITE VAMPIRE

A JOLLY LUMBERJACK

EXERCISE 60

Create an alternative version of yourself or a friend in a different universe or time period—harsh tundra, space opera, apocalyptic future, etc. What would change and how would you portray yourself in this universe?

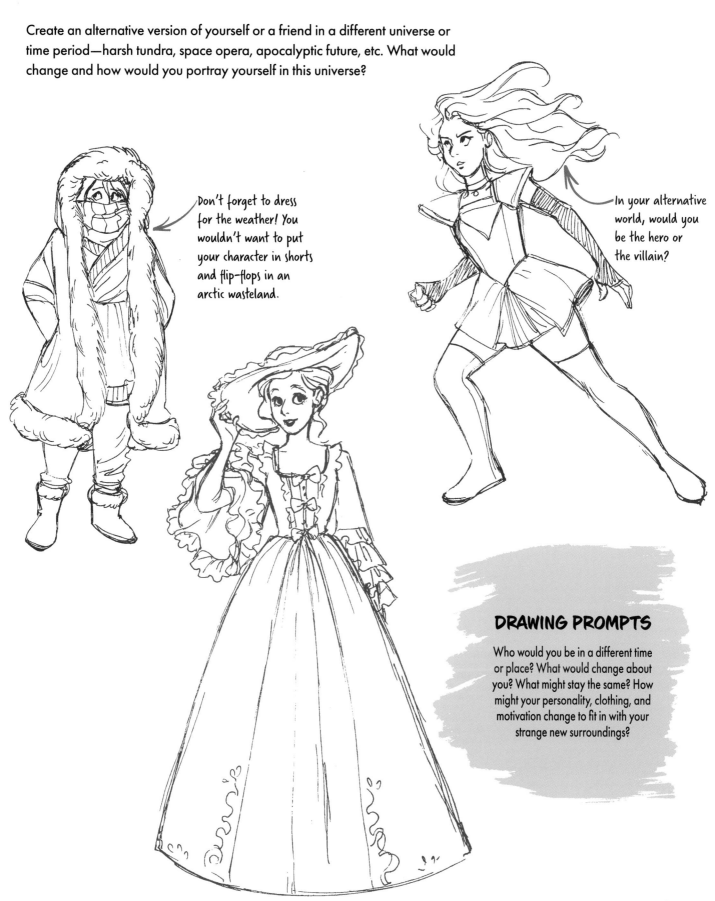

Don't forget to dress for the weather! You wouldn't want to put your character in shorts and flip-flops in an arctic wasteland.

In your alternative world, would you be the hero or the villain?

DRAWING PROMPTS

Who would you be in a different time or place? What would change about you? What might stay the same? How might your personality, clothing, and motivation change to fit in with your strange new surroundings?

EXERCISE 61

Project fashion 200 years into the future. How do you think people will dress in two centuries? Which styles will remain or be revived and which will be super-outdated?

Remember that hairstyles are a big part of personal fashion. Will future hairdos be more reserved or more eye-catching?

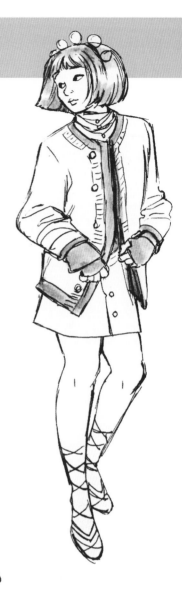

Might shoes become bigger one day, with tall platforms? If that's an aspect of fashion you like, maybe they should!

DRAWING PROMPTS

Beyond imagining how things might look in a science-fiction future where everyone wears silver spandex, look to the past, too. How many fashions of days gone by have come back into style? What might return in two centuries' time? When did the men's necktie originate, and how has it evolved over the years? Can that history help you predict in your sketches how it might look next? Pick fashion accessories that interest you and see where they've been to help you imagine where they might be going generations from now.

Create a functional outfit for a survivalist or superhero.
Think of practicality and functionality.

DRAWING PROMPTS

What clothing might such a superhero character
need to survive? Your locations and the situation
will dictate how your superhero needs to suit up.
If your hero often travels into deep space, you'll
need to consider reserves of oxygen and other
essentials. If your hero lives deep below the
planet's surface to stave off invasions from the
Gopher Lord's burrow brigade, he'll need lights
to see them coming. Is your hero in the middle
of a vast ocean, or at the bottom of a watery
trench? If so, some kind of underwater breathing
apparatus will be essential. If your hero teleports
back and forth between a pleasant earth
location and a hostile dimension, that may call
for a suit that changes to fit each environment.
What situations can you think of for your hero?

Form might follow function,
but it can also be fashionable!
These stylish shoulder
extensions might serve as
pneumatic propulsion pads!

This character has streamlined her
ensemble for ease of movement. But
if yours is near the lava pits, that
may involve bundling up in bulky
fireproof gear. Dress accordingly!

EXERCISE 63

Sketch different shoes based on only a single adjective for each.

CHUNKY

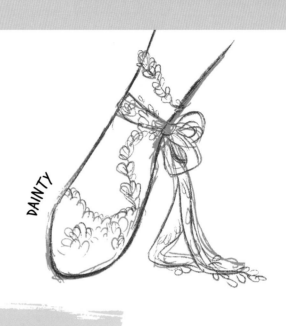

DAINTY

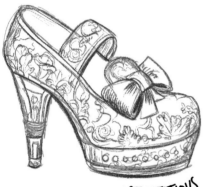

OSTENTATIOUS

DRAWING PROMPTS

How many shoes can you come up with? Well, how many adjectives are there that interest you? "Floppy" might bring to mind fishermen's waders, which would fall right over when not being worn. The word "Soggy" conjures snug-fitting neoprene booties that a surfer might wear while riding the waves. Here are a few adjectives to get you going with your own shoes. Then try coming up with your own descriptive words to continue the fun.

Tall • Sturdy • Worn • Ridiculous • Bouncy • Scary • Sporty • Festive

DRAB

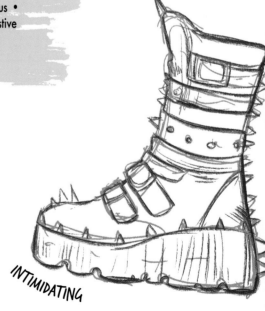

INTIMIDATING

Design objects based on a single word.

HAUNTED

PRISSY

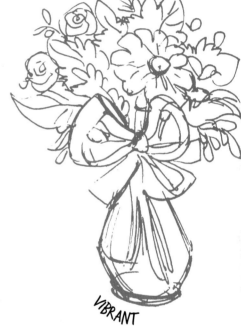

VIBRANT

DRAWING PROMPTS

Sketch your own unique objects based on the words illustrated here. Prissy, Bejeweled, Vibrant, Haunted, Abandoned. Or add to those objects with words from the following list:

Soggy • Broken • Rubbery • Frozen • Fanciful

Extra points if they're all the same object sketched in different ways!

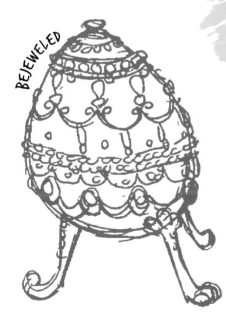

BEJEWELED

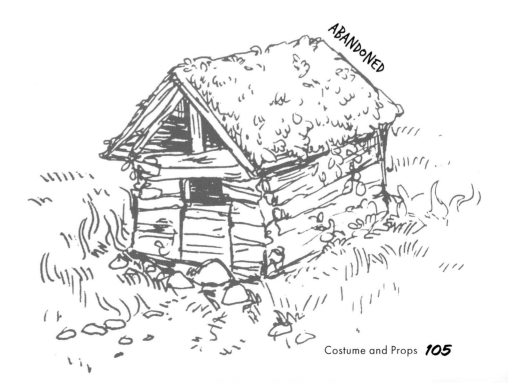

ABANDONED

EXERCISE 65

Think of your own fashion sense and the things that are most important to you. Sketch a diagram—what outfit would you wear as a cartoon character? What accessories would you have?

DRAWING PROMPTS

If you were a cartoon character, who would you be? Would you be a happy character in a musical movie? A high-energy, leaping hero in an exciting anime adventure? A gentle narrator in an educational program on public television? Decide your cartoon identity, and your fashion sense will follow as a result. What type of character are you?

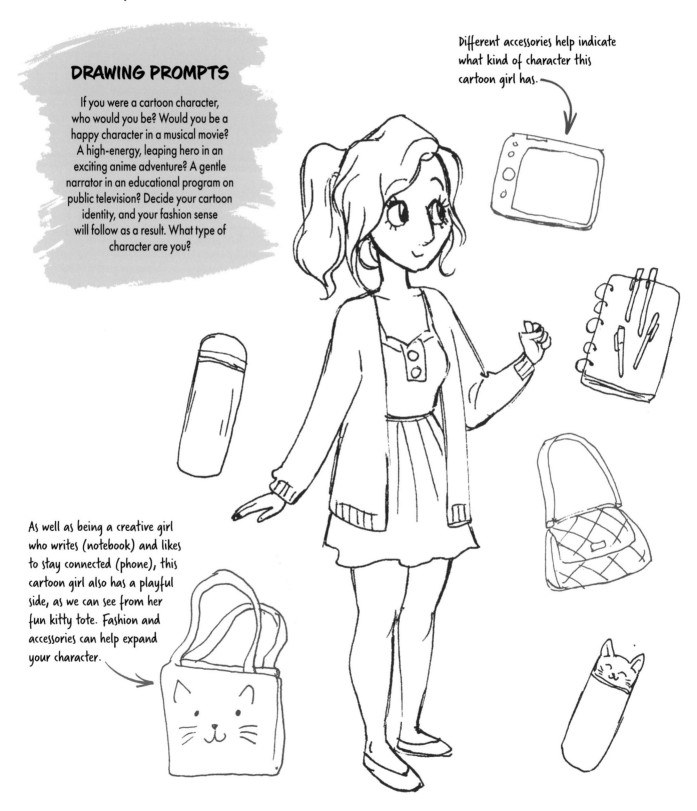

Different accessories help indicate what kind of character this cartoon girl has.

As well as being a creative girl who writes (notebook) and likes to stay connected (phone), this cartoon girl also has a playful side, as we can see from her fun kitty tote. Fashion and accessories can help expand your character.

EXERCISE 66

Choose one character, either your own or an established favorite. Sketch their own personal spin on the following types of outfits.

Note how each outfit tends to change the wearer's behavior and personality. It's hard to pull off the scowling vampire look if you're dressed in a sweatshirt and pants!

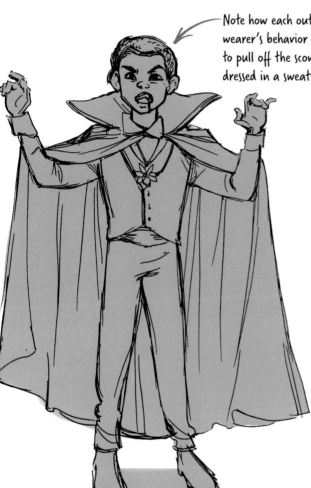

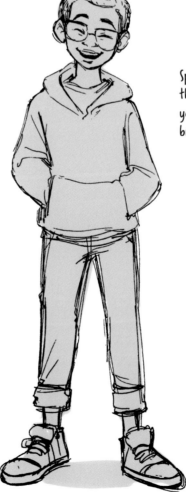

Sportswear gives your character the freedom to jump around—you couldn't do that in a smart business suit!

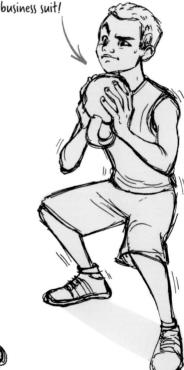

DRAWING PROMPTS

How do you feel when you wear something different from your usual clothing? When dressed up for Halloween, would you feel suddenly reserved or free to have fun? If you decide to exercise or work out, would you dress in formal wear or in something comfortable that can take a certain amount of stress and strain? Think about how you feel in varying outfits. What makes you feel comfortable? What makes you feel stiff and awkward? Impressive or proud? Adventurous? Silly? Convey those feelings through your character.

Take one character and show how simply changing their clothes can make them appear very different.

Dark glasses, a diamond collar-style necklace, and a flamboyant evening dress make this character look like an A-list celebrity, or perhaps a famous heiress, dressed to impress.

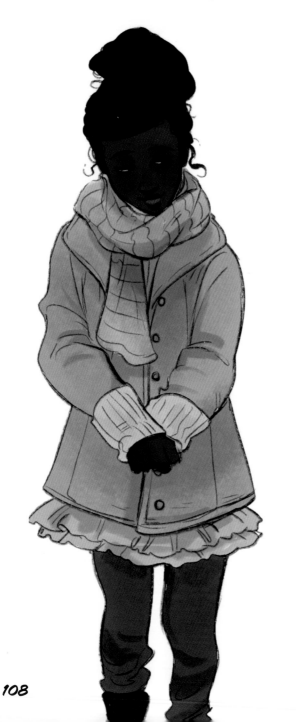

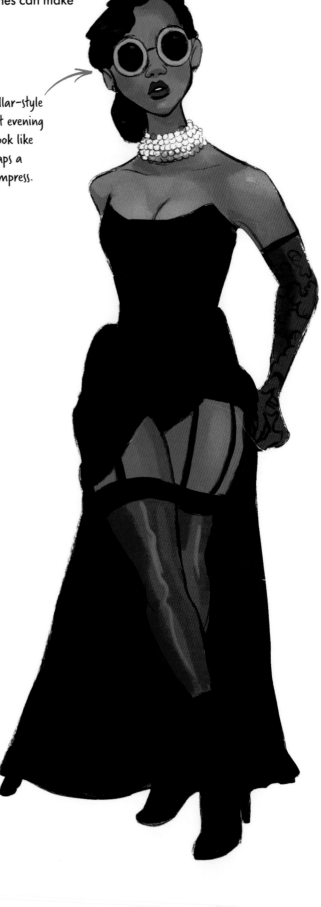

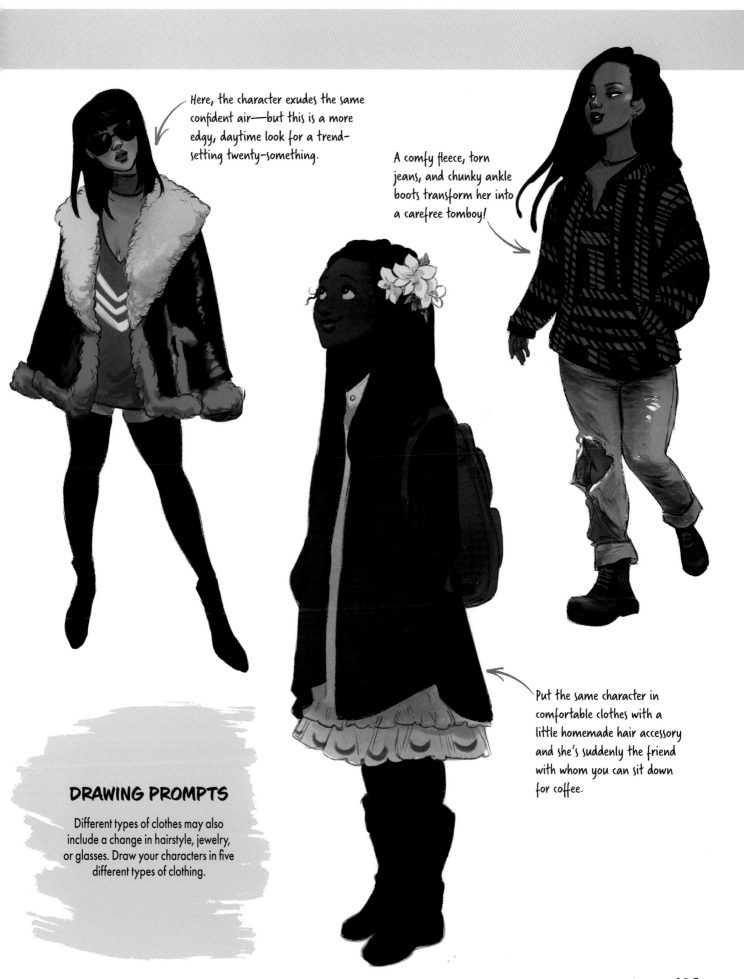

Here, the character exudes the same confident air—but this is a more edgy, daytime look for a trend-setting twenty-something.

A comfy fleece, torn jeans, and chunky ankle boots transform her into a carefree tomboy!

Put the same character in comfortable clothes with a little homemade hair accessory and she's suddenly the friend with whom you can sit down for coffee.

DRAWING PROMPTS

Different types of clothes may also include a change in hairstyle, jewelry, or glasses. Draw your characters in five different types of clothing.

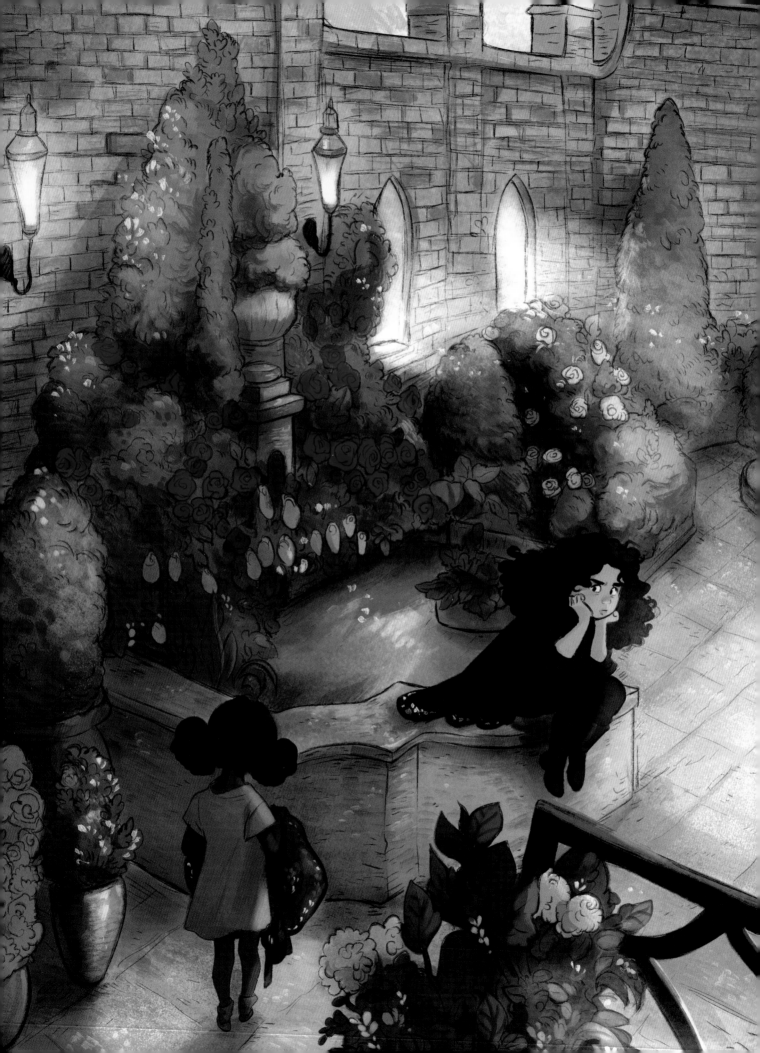

7

DRAWING FROM LIFE

No matter how much we can get from our imagination, there is nothing more important than drawing from real life. You will learn more from looking at the world around you than in any other way. The imagination is a powerful thing, but it needs material to work with. Even if your characters live in a fantastic futuristic city and fly around in glider cars, a good study of actual towns and cities, of real automobiles and aircraft, will help you build a foundation to work from. If you find yourself having difficulty drawing something and trying over and over to little effect, turning to the real world can solve that problem. Can't get your character's clothing to look quite right? Look at clothing in real life. How does the clothing fit a person's body; how does it wrinkle and fold? Do the character's surroundings seem off to you? Look at your own surroundings and draw from that.

Whatever we can dream up for our characters, life itself has done it first in some form or another. Always draw from life whenever you can. Your drawings will then improve in leaps and bounds.

EXERCISE 68

One of the most convenient ways to draw from life is to sketch yourself.

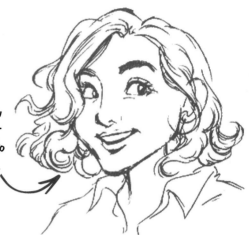

As a warm-up, begin with standard expressions—smile, frown, anxious, suspicious—and then build from there to a wider range of expressions.

DRAWING PROMPTS

Observe yourself. Look in a mirror or even take pictures of yourself in various poses. Take note of your distinct features and gestures. You can try on different clothes, hold props, or do whatever you like when studying yourself. This is one time that your model will never complain.

Try moving around and change your pose smoothly, as if something just caught your eye. Then freeze at some point along the way. Sketch that expression.

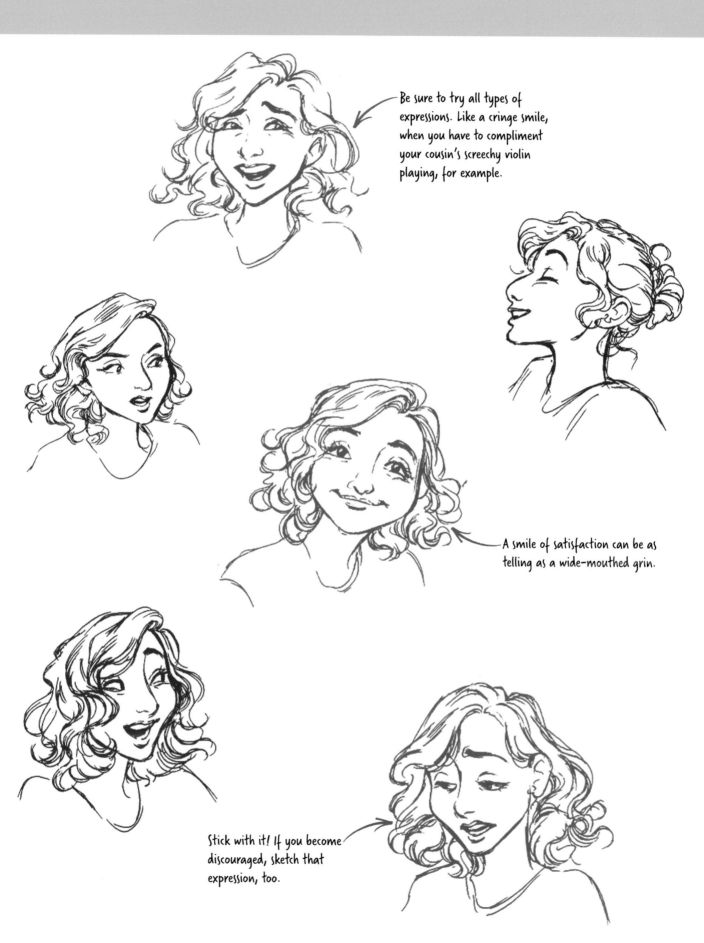

Be sure to try all types of expressions. Like a cringe smile, when you have to compliment your cousin's screechy violin playing, for example.

A smile of satisfaction can be as telling as a wide-mouthed grin.

Stick with it! If you become discouraged, sketch that expression, too.

EXERCISE 69

Think of a friend or celebrity who has an interesting range of expressions. Sketch an expression sheet of them.

It is always interesting to see the way celebrities express themselves during performances when they assume a character as opposed to how they behave during an interview when they are being themselves.

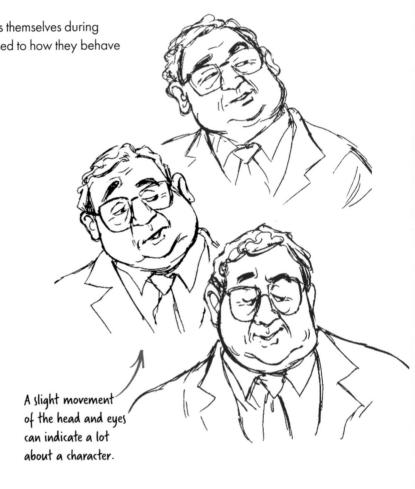

A slight movement of the head and eyes can indicate a lot about a character.

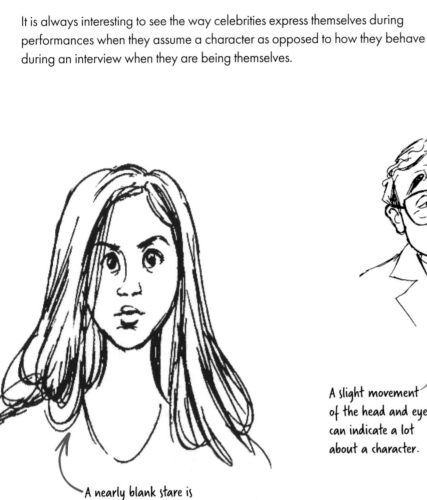

A nearly blank stare is an expression in itself.

Irritated, tired, or bored? It's possible for one expression to express all three emotions.

Some people always seem to be cheery. But see how many ways you can express different attitudes and responses while maintaining that positivity.

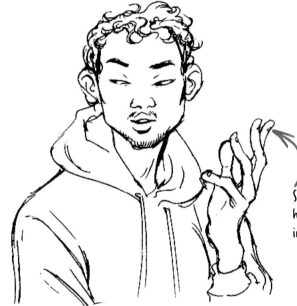

Some people gesture with their hands while speaking. Use that in some of your sketches.

Some people speak mostly with their eyes, as their posture seldom changes.

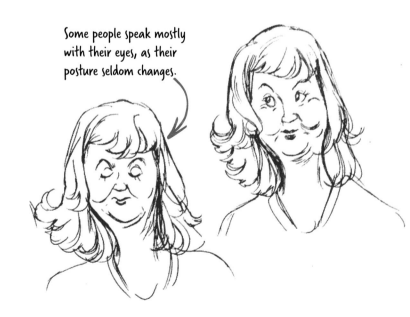

DRAWING PROMPTS

Some basic expressions to look for include the following:

Sincere smile • Disapproving frown • Shout of rage • Squeal of surprise • Thoughtful pause • Robust laughter • Listening intently

EXERCISE 70

Do quick sketches of people in real life—at a café, in a library, or on a bus.

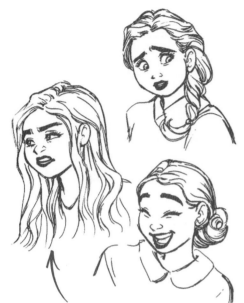

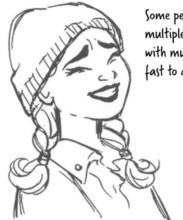

Some people have on multiple layers of clothing with multiple folds. Sketch fast to get them down!

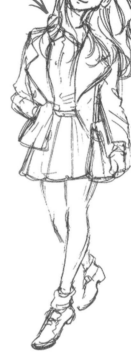

Try to capture expressions in as few line strokes as you can.

DRAWING PROMPTS

When we say quick, we mean quick! People in real life will not hold a pose for a long time for us to sketch from slowly. Rapid gestures scribbled out in just a few seconds can give you the framework of a person's movements or expression to expand on later from memory or apply to one of your own characters.

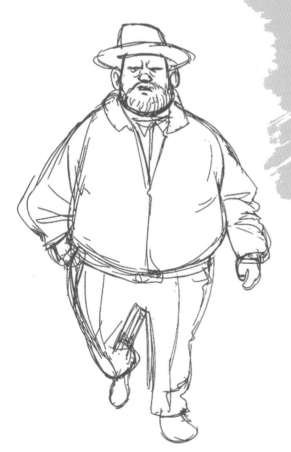

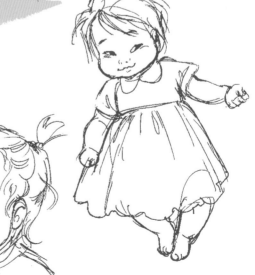

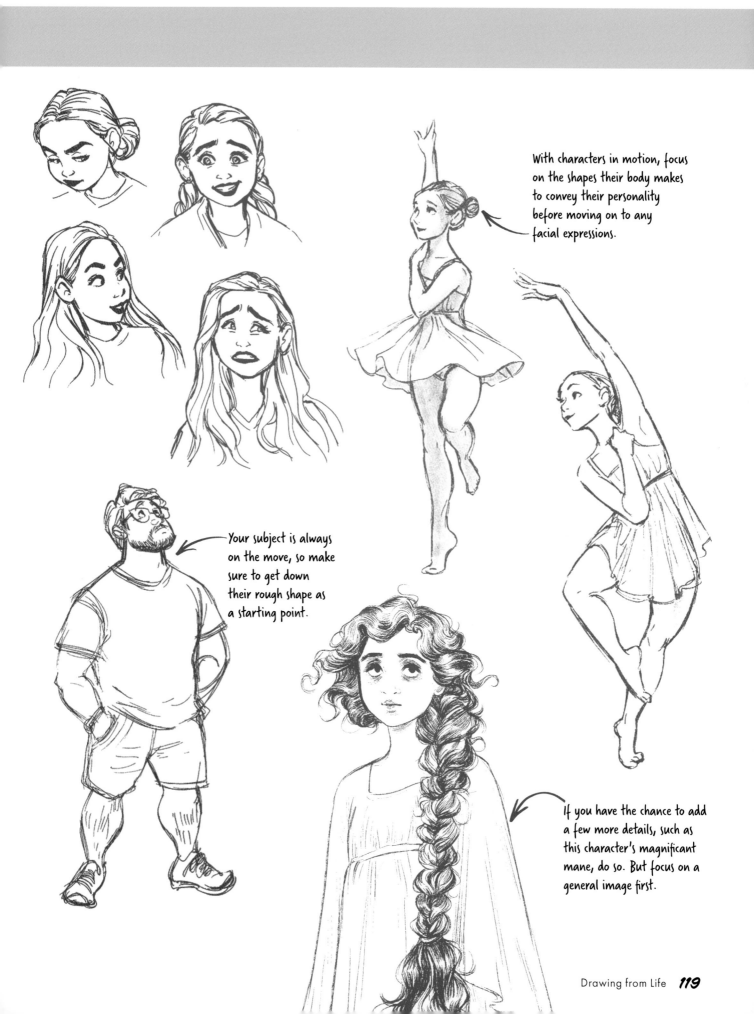

With characters in motion, focus on the shapes their body makes to convey their personality before moving on to any facial expressions.

Your subject is always on the move, so make sure to get down their rough shape as a starting point.

If you have the chance to add a few more details, such as this character's magnificant mane, do so. But focus on a general image first.

EXERCISE 71

Watch videos of dance or roller-skating routines and draw their various movements and poses.

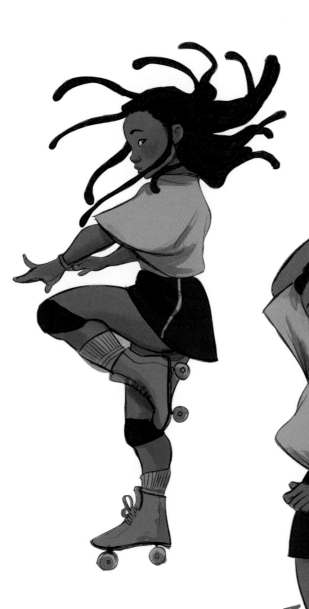

Capture how everything moves when the skater is in motion! The clothing, the hair, how the gestures change rapidly. See if you can create that sense of motion on the page.

DRAWING PROMPTS

Notice how differently someone gliding on skates moves, compared with the way a person moves when they are walking or running.

Hand and arm positions can tell you a lot about a character's mood. Model some general poses or have a friend pose for you.

DRAWING PROMPTS

A change in the position of a character's hands and arms can create a totally different mood. Some poses to help you include:

- Head in hands, in despair.
- Shoulders shrugging and palms turned upward.
- Cowering in fear.
- Arms stretched out in welcome.

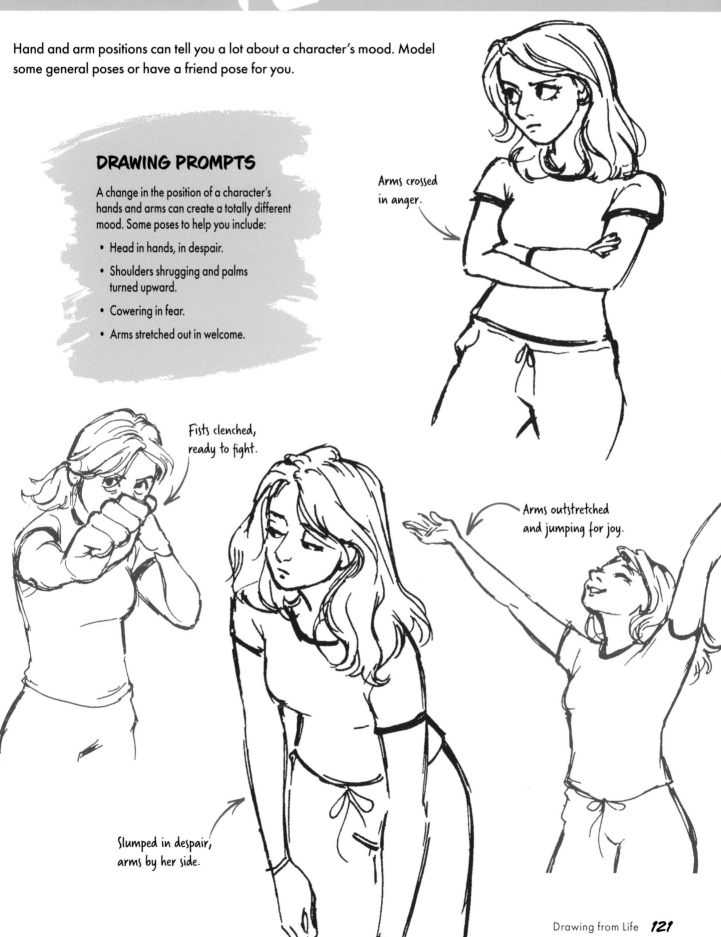

Arms crossed in anger.

Fists clenched, ready to fight.

Slumped in despair, arms by her side.

Arms outstretched and jumping for joy.

EXERCISE 73

Sketch 50 hands from observation.

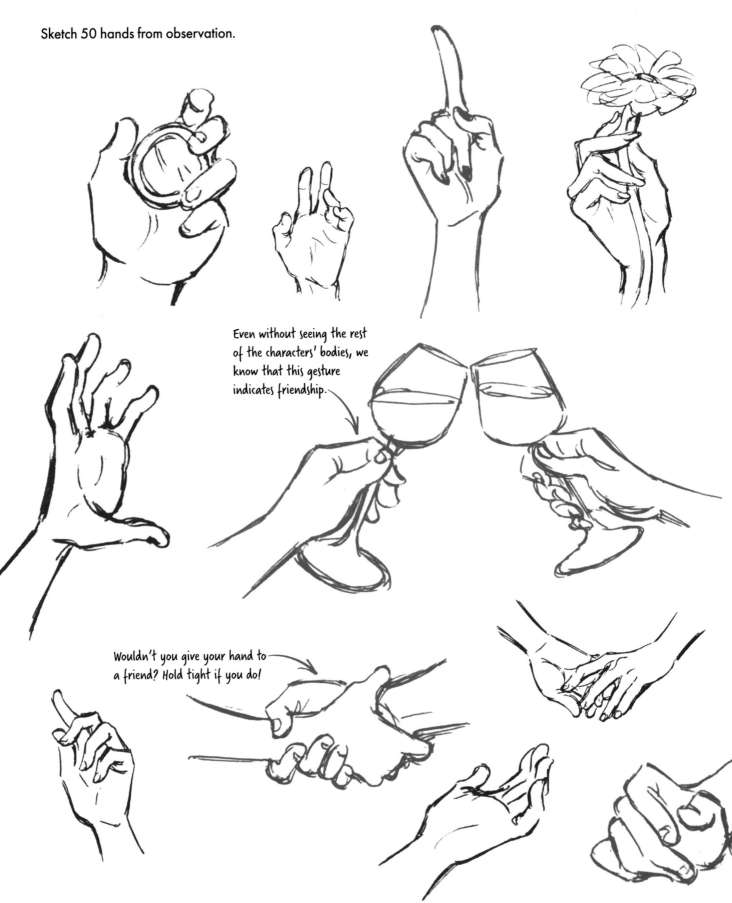

Even without seeing the rest of the characters' bodies, we know that this gesture indicates friendship.

Wouldn't you give your hand to a friend? Hold tight if you do!

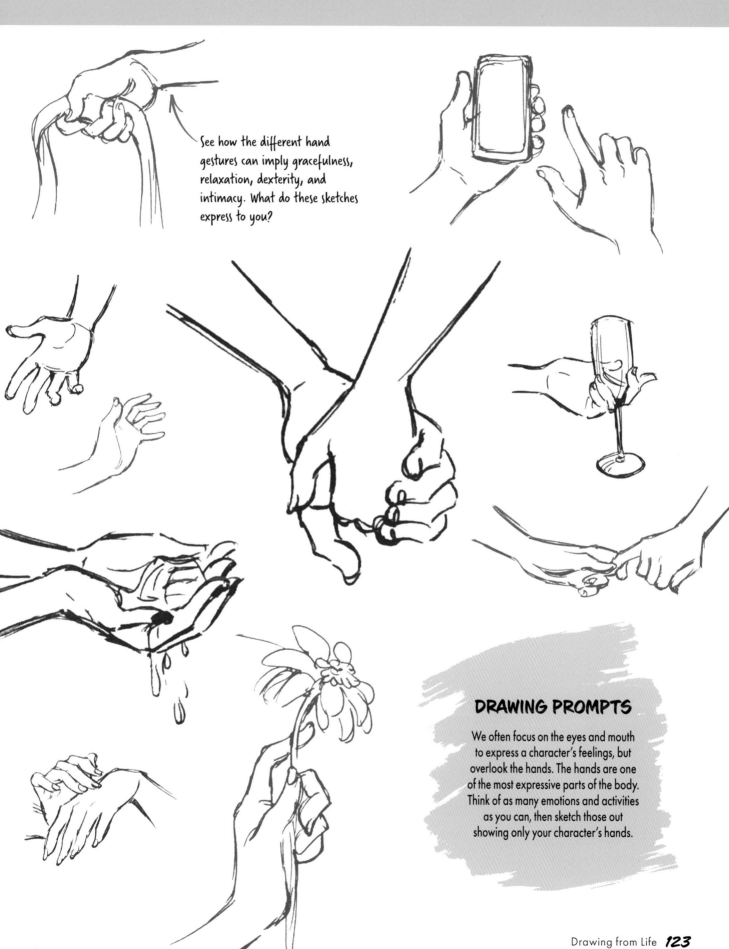

See how the different hand gestures can imply gracefulness, relaxation, dexterity, and intimacy. What do these sketches express to you?

DRAWING PROMPTS

We often focus on the eyes and mouth to express a character's feelings, but overlook the hands. The hands are one of the most expressive parts of the body. Think of as many emotions and activities as you can, then sketch those out showing only your character's hands.

EXERCISE 74

Do observational drawings of people or characters you often have a hard time drawing. What aspects of those characters make them difficult to draw? Can you make those aspects fun?

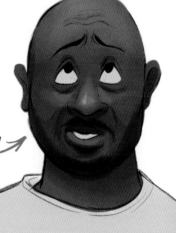

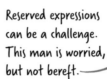

Reserved expressions can be a challenge. This man is worried, but not bereft.

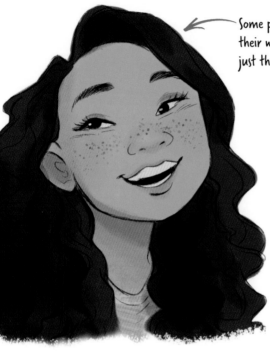

Some people smile with their whole face, not just the mouth!

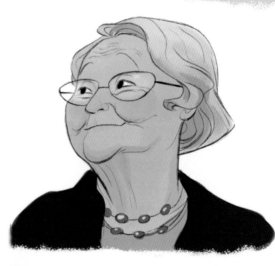

A small expression of the eyes can indicate a whole lot of attitude. Sometimes less is more.

If we're used to a character who laughs raucously, one with a quiet titter will prompt us to reduce our own enthusiasm.

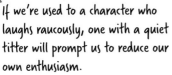

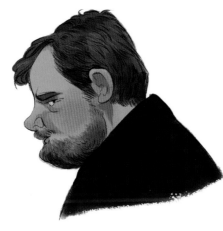

A character without any pronounced features can make it difficult for you to know where to begin.

DRAWING PROMPTS

Make a conscious effort to draw people of different ages, so you're exposed to a wide range of facial types and expressions. Here are some more challenging ideas for you to try:

- A young man with flowing dreadlocks and a beard.

- Well-defined muscles on someone who works out a lot.

- Wrinkles and "laughter lines" on the face of an elderly person.

- A chubby baby's face, where the features are less pronounced than those of an adult.

This fellow may be thinking, daydreaming, or watching a bird fly by. You don't always have to spell everything out in your drawing.

EXERCISE 75

Draw your friends and family, carefully observing their unique gestures and expressions.

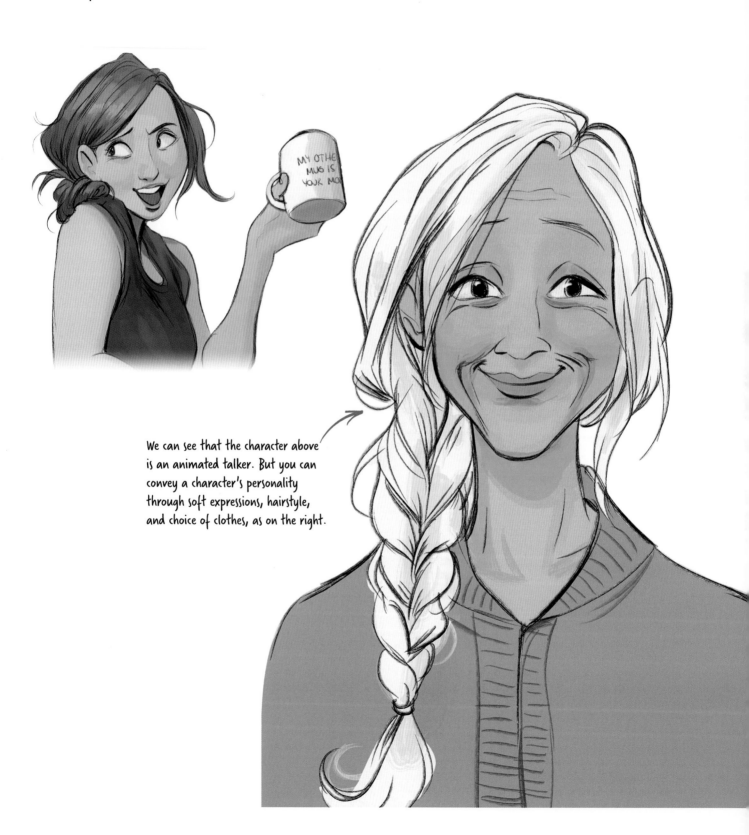

We can see that the character above is an animated talker. But you can convey a character's personality through soft expressions, hairstyle, and choice of clothes, as on the right.

Each of these characters is smiling, but each one looks different. We can see a satisfied smile, an impish grin, and a jocular, beaming smile. That's just three people! How many varieties of expression and personality can you give your characters?

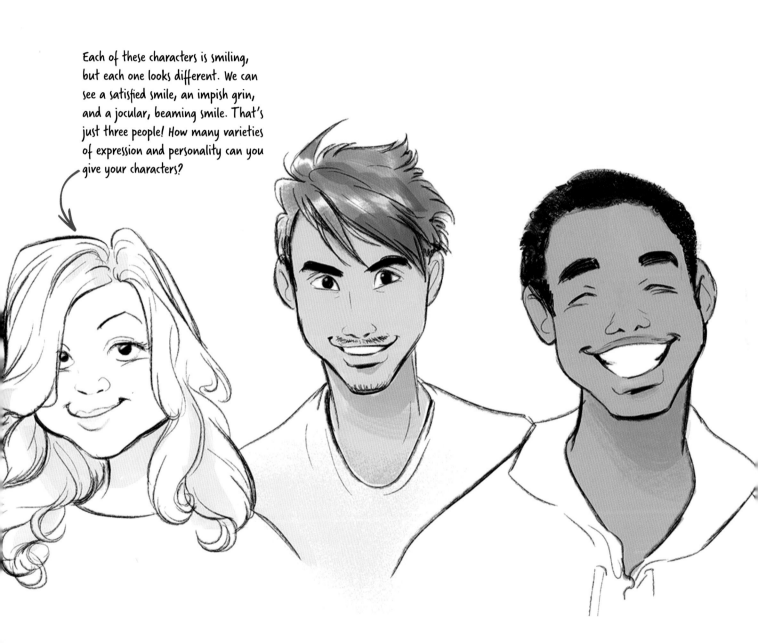

DRAWING PROMPTS

We tend to notice the little quirks and behaviors of those closest to us that others may not pick up on. Translate those observations onto the page to help bring your character versions of friends and family to life.

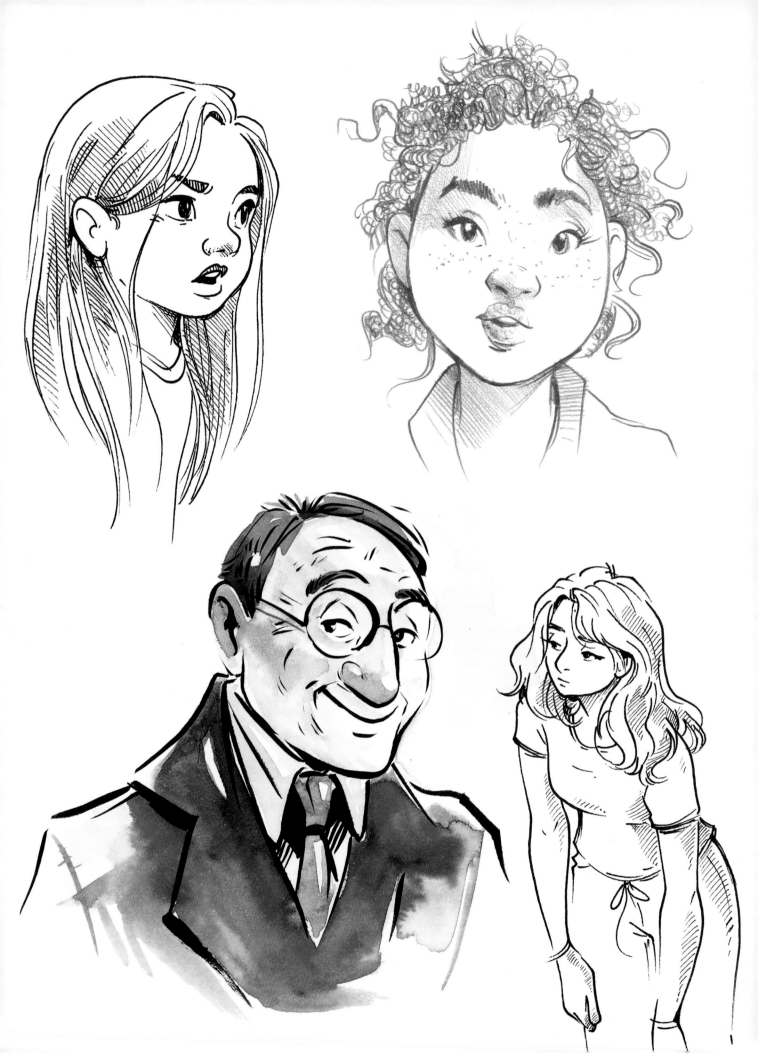

DRAWING TECHNIQUES

Drawing is one of the most basic ways to exercise your creativity. For many artists, pencil drawing is the skill that introduced them to the art world. Understanding how to draw with pencil can help you improve your skills elsewhere.

Here, I will introduce you to standard drawing techniques that you need to be familiar with before you put pencil to paper. Some are so basic that you've probably used them before without even realizing it.

After the initial pencil drawing is complete, the addition of color will bring contrast, depth, and life to your characters, allowing you to infuse them with extra layers of interest.

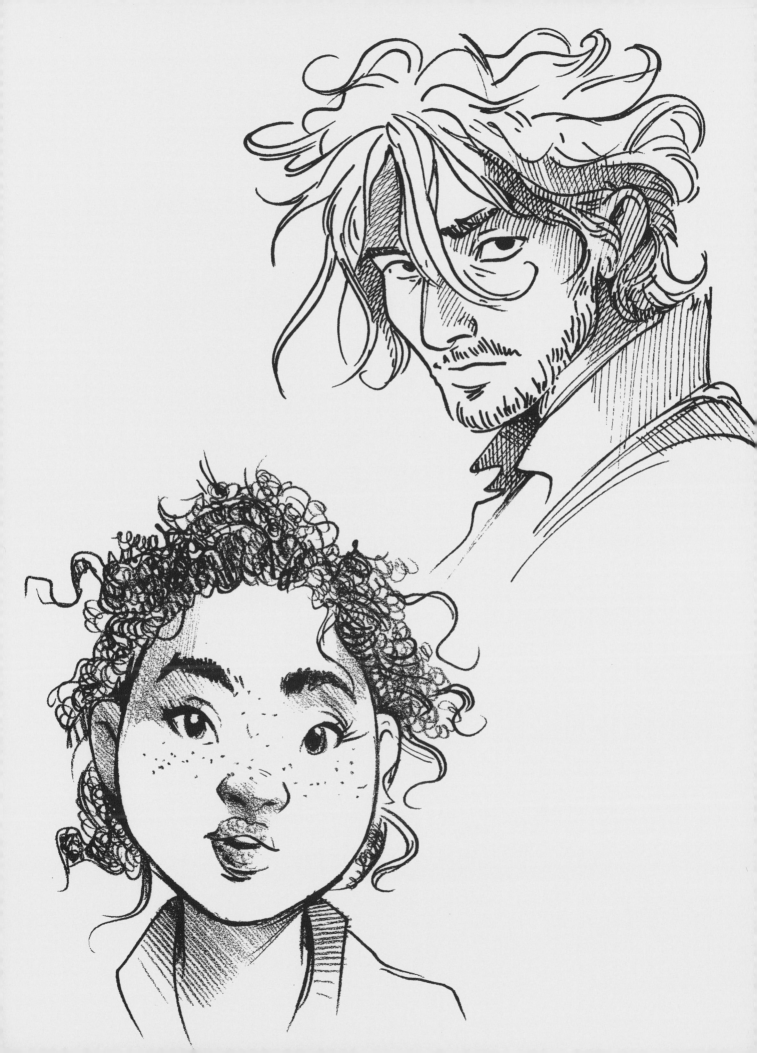

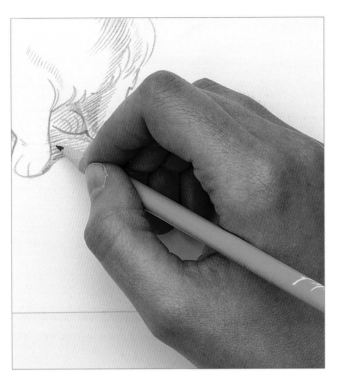

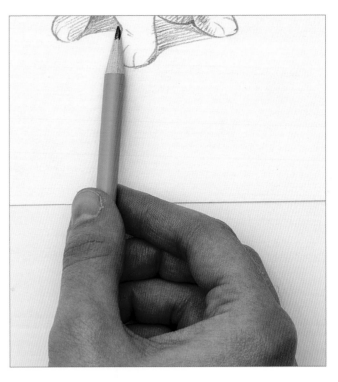

TRADITIONAL GRIP

For the standard grip, make sure to have the pencil resting comfortably on your middle finger and grip it with your index finger and thumb. This standard grip gives the greatest degree of control.

THE DRUMSTICK GRIP

Holding the pencil higher up the shaft and more loosely enables you to make more gestural marks. This grip is useful for drawing more or less at arm's length.

HOLDING YOUR PENCIL

There are several ways you can hold your pencil when it comes to coloring. These variations will achieve different textures on paper. Furthermore, changing the pressure on your pencil will also change the tone and texture.

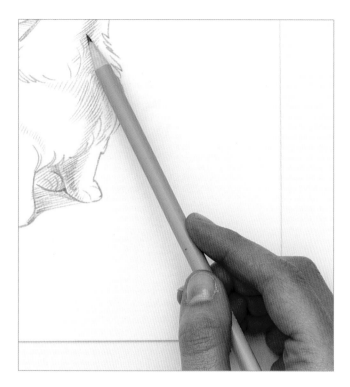

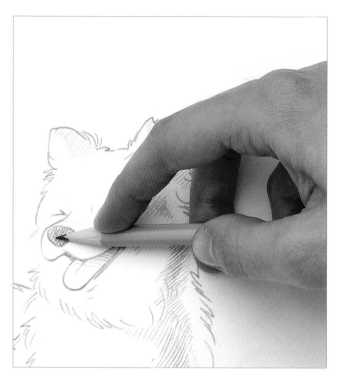

PAINTBRUSH GRIP

To produce dense shading or a strong line, try placing your forefinger over the shaft of the pencil and pushing the lead down onto the paper.

TIP-HEAVY OVERHAND GRIP

In the overhand grip, the pencil is held between the thumb and two forefingers, which is useful for both shading and creating a heavy line.

INVERTED GRIP

For this grip, the pencil is held by resting it upon the forefinger and stabilizing it with the thumb and lower fingers. Marks are made with the tip and the backside of the tip of the pencil. This grip allows the artist to see the marks clearly as they are made, since the hand and the fingers are out of the way.

CONTROLLING LINE WEIGHT

One of the coolest aspects of working with drawing materials is the amount of control you have over line weight and stroke. Line weight refers to the lightness and thinness, or darkness and thickness, of a line. Different pens or pencils create different strokes.

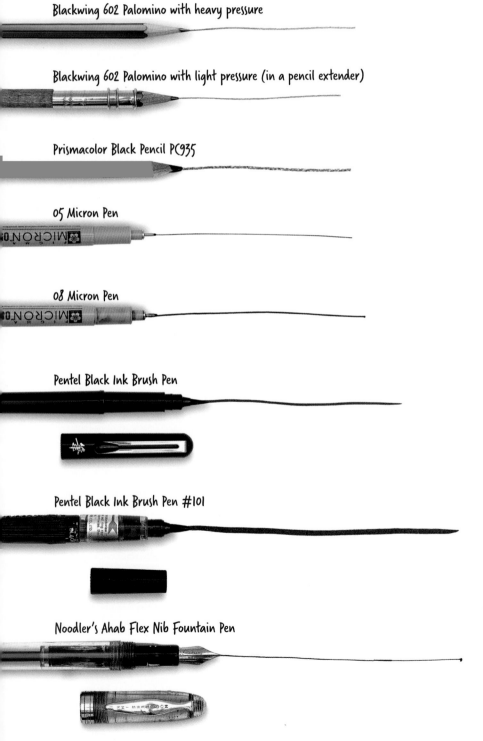

Blackwing 602 Palomino with heavy pressure

Blackwing 602 Palomino with light pressure (in a pencil extender)

Prismacolor Black Pencil PC935

05 Micron Pen

08 Micron Pen

Pentel Black Ink Brush Pen

Pentel Black Ink Brush Pen #101

Noodler's Ahab Flex Nib Fountain Pen

PENCILS

Held with or without a pencil grip, a useful pencil is the Blackwing 602, which gives a range of tones, depending on the pressure that is applied. The easily blended Prismacolor black pencil is sometimes used to make darks darker.

TECHNICAL PENS

Technical pens, such as Micron markers, offer a very consistent mechanical line that is waterproof. The 05 is for refined details, such as facial features, and the 08 is good when a thicker line is needed. Avoid applying too much pressure; you only need to touch the page to release the ink.

INK BRUSH PENS

Brush pens are like painting with watercolor but without a brush. Pens come in different line weights. Light pressure creates thin strokes, whereas heavy pressure creates thicker strokes.

FOUNTAIN PENS

Some illustrators use fountain pens for sketching. You'll need to find a truly flexible nib, however. This type of pen produces a lovely, wet line.

HATCHING

Hatching is a mark-making technique that is used to create shade, tones, and textures through the use of close parallel lines. The distance between the lines will determine how light or dark the area will be. More space between lines gives lighter tones; denser spacing makes darker tones.

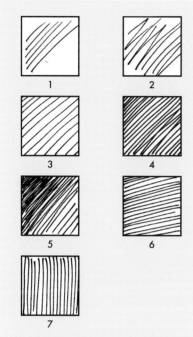

Hatching lines are generally drawn as separate lines (**1**) with the pen or pencil lifting at the top and bottom of each stroke. If you are working quickly, the pen might not lift and instead create an angled join (**2**). This will give the work a slightly more spontaneous feel, as will slight irregularities of the start and finish of the lines in both (**1**) and (**2**).

It's a good idea to practice swatches. See how big an area you can complete with just parallel lines. Rest the side of your hand on the surface (for control) and work the pencil or pen from side to side.

Lines can create a light tone if spaced apart (**3**). Lines drawn closer together create a darker tone (**4**). By adding more hatching to certain areas you can vary the tone (**5**). Hatching can be drawn at any angle. Here (**6**) it is almost horizontal. Hatching lines can also be vertical (**7**).

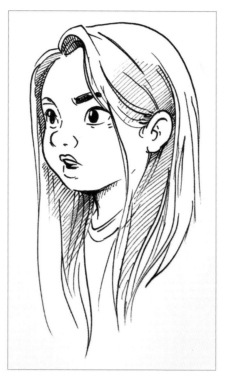

1 Start parallel line hatching, working the hatching on the diagonal, so linear hair strands are still visible. By shading the hair on the right side of this character's face, the shape of her profile stands out. Here, most of the shading is fairly even, with some denser line hatching under the chin to give depth and definition.

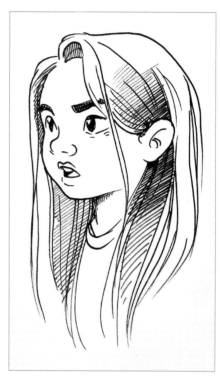

2 Add an extra layer of hatching to the hair strands around the ear. (When the ear is more defined, the whole head has more form.) Work the little hatching lines on the neck under the chin on a different diagonal angle—this will help to explain the two different surfaces of the hair and the neck.

Here you can see the range, from deepest shadow to light. When drawing with pen, the only thing to make shadow deeper is to draw the lines densely. Using pencil makes it possible to vary the shadow, not only through the density but also through the intensity of the lines used. For deep shadow, use dense and strong lines; for light shadow, use thin, delicate lines.

CROSSHATCHING

Crosshatching is similar to hatching, but the lines cross over each other. You can be as systematic as you like depending on your style and the amount of patience you have. Similar to hatching, you can also use these as contour lines to define a shape or an object.

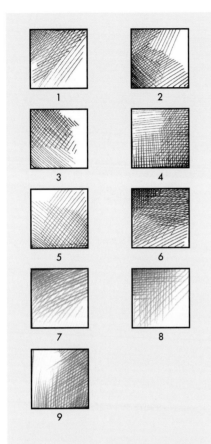

These swatches show different angles of line and tone, from the simple, two-layer, right-angle crosshatch (5) to some that have three and even four layers at different angles and in deeper tones.

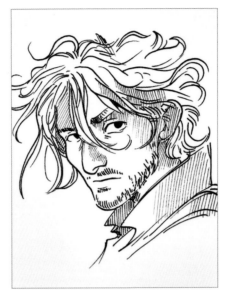

1 As with hatching, apply a first layer of angled strokes to the shadow areas, working within separate small shapes of the strands of hair and face. The shading has generally been placed around the face to give emphasis to this character.

2 Add a second layer of hatched lines at different angles from the first layer. Experiment with a set of parallel lines traveling in the same direction or vary them, as here. Add a third angle under the chin for extra emphasis.

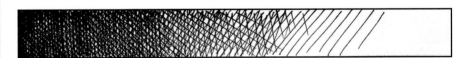

This horizontal bar swatch shows the buildup of a strong tonal range from light to dark. You can see that left and right diagonal lines and vertical lines have been used. Crosshatching brings more character and life to drawings when compared to the straight, single vertical hatching shown on the previous page.

CONTINUOUS AND FLAT-AREA SHADING

Continuous shading is a way of capturing a gradual transition from light to dark, where there are no visible lines from the drawing medium. Flat-area shading involves working out the similar areas of color tone and rendering them as evenly as possible.

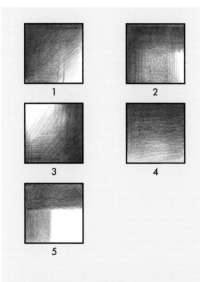

You can see some of the pencil lines in the layers of these swatches. One way to lose these is to rub the tone gently with your finger.

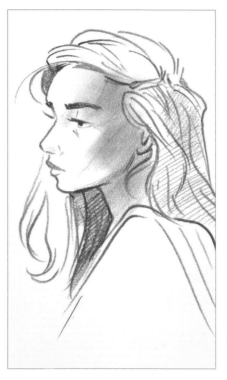

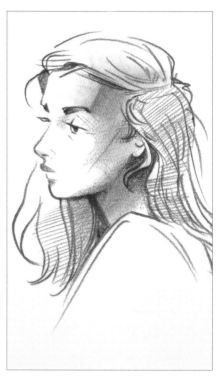

1 Apply the first layer of very fine, soft shading to the skin. The trick, with whatever medium you are using, is not to let any linear buildup show. Here, the tones in the hair are made using hatching to create contrast.

2 Repeat the process until you are satisfied with the depth and darkness of the shading.

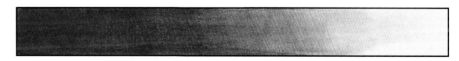

Although slight linear marks are visible, you can see how by using this method of shading, it is possible to create a very gradual transition from light to dark.

SCUMBLING

This is a softer approach to shading that uses random scribbly lines. As with the two hatching techniques, the closer together and the more overlapped the lines, the darker the value. This method is a bit more forgiving than hatching and crosshatching because the marks are less precise.

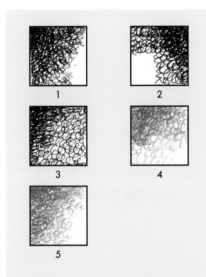

Practice filling different areas using different media. Squares **1** to **3** have been filled in with a soft 2B pencil, making darker tones. A harder HB pencil has been used for squares **4** and **5**.

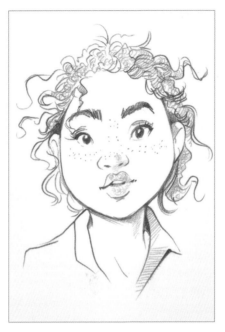

1 Draw the basic shapes of the curls, then, as a first layer, gently make circular or E-shaped marks within the curls. These marks don't need to be complete to achieve the look.

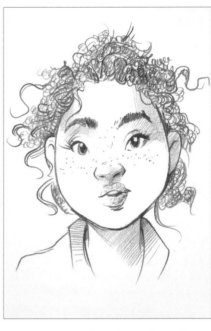

2 Continue making the marks until you have built up the desired hair shape and tone.

The tone is gradually built up and requires less precision than the hatching techniques.

STIPPLING

This technique involves making a series of dots by touching the tip of the pencil to your paper. The closer the dots, the darker the value. This can be time-consuming, but it allows for a high level of control in the depth of shading within your characters.

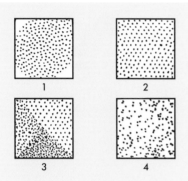

Practice different ways of placing the dots. For absolute precision, hold the pen or pencil with your hand firmly on the paper. Keep your hand still and, using only your fingers, move the pen to make the dots.

To create evenly spaced dots, try working in a spiral as this naturally offsets as the spiral gets bigger (1).

Working from left to right, offset each row like building bricks (2). Square 3 shows a progression from a light tone to the darkest tone, achieved by increasing the number of dots across each quadrant.

Using more movement in your hand, you can apply randomly spaced dots in layers (4).

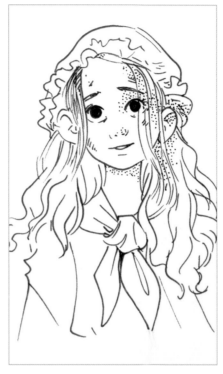

1 As with most shading techniques, it is easiest to put a pale layer of tone down first. This helps you see the tonal areas, and you can build up darker layers on top. Carefully stipple in evenly spaced areas of dots.

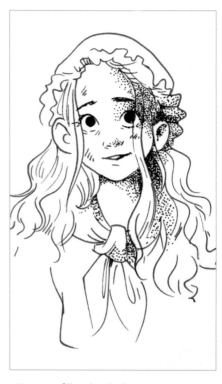

2 Now fill in the darker areas with extra stipples. You can keep adding dots to these areas until they are almost black in tone in places.

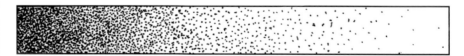

For really smooth transitions of tone, try to maintain your dot size (i.e. keep the pressure similar) and make the spacing between the dots similar.

LINE AND WASH

Pen and watercolor

Adding color to your figures gives you more opportunity to explain the character. You can choose colors for the hair, skin, and clothes—all of which will add to your character's narrative. The method used here can be applied to all characters.

 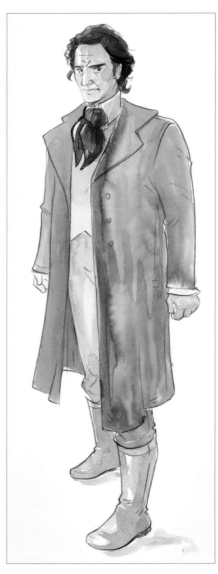

1 Draw a delicate pencil sketch. Having the rough shapes in place first means the painting or inking is easier and you can then concentrate on the painting technique without having to think too much about the shape.

2 Plan your colors roughly, grading them from light to dark, then start painting with the lightest. I put a weak yellow wash over the facial skin tone, then added a very pale wash of burnt sienna to start the shading on this character's breeches.

3 Start painting the details of the cravat and hair—I used pale washes of Venetian red and black, and a mix of Venetian red and burnt sienna, respectively. I applied the washes very thinly, leaving highlights of white from the paper.

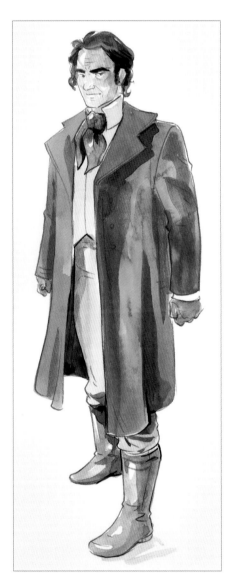

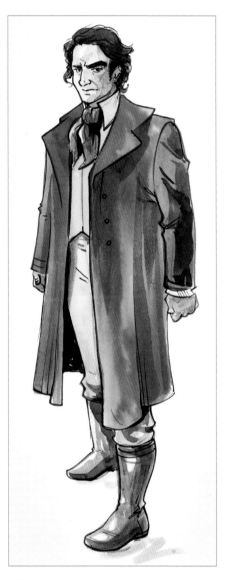

You will find that you can make a wide variety of different marks using a brush pen—from fine and sensitive lines to broad blobs and shapes of various kinds.

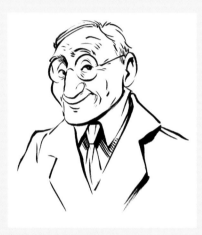

1 Draw the outline of the character, holding the brush close to the point for maximum control.

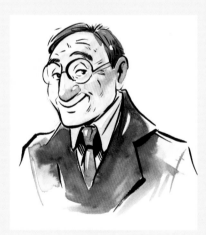

2 Fill the character with color from light to dark, then go over the outline with a brush pen.

4 Use the paint mix to add some shadows to the hair.

5 Add more shadow wash to the inside of the coat and to the sleeve. Let dry, then go over the general shape of the character with an ink pen outline to crisp up the edges. Use the ink pen to emphasize the character's sardonic expression and remember to include some button detailing.

INDEX

Illustrations are in *italic*.

CREDITS

Thank you to my family and friends for believing in me
and supporting me since I was a little kid! Thank you to
all the teachers and professors who've encouraged me
and helped me to grow creatively, and everyone else who
gave me opportunities to draw and express myself.

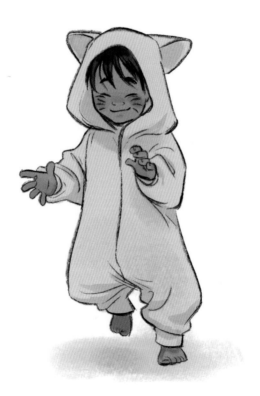